THE POTTERIES
THROUGH TIME
Mervyn Edwards

AMBERLEY

Acknowledgements

John Bennett, Roger Billington, Laura Butler, Neil Collingwood, Ken Cubley, the William Blake Collection, Jim Dutton, Hector Emanuelli, L. Griffiths, Stanley Hancock, Bill Harrison, Harry and Don Hickton, Geoff Hill, John Lees, Mrs P. Lovatt, Gerrard Mosely, Gladstone Pottery Museum, Hanley Market traders, Keith Meeson, Doug Millington, Harry Mountford, Alan Myatt, National Coal Board, Old Nortonians Society, David Orlando, Clifford Proctor, Alan Salt, Norman Scholes, John Scott, Derek Tamea, Gary Tudor, the Warrillow Collection at Keele University Library, Hilary Whalley, Barbara Whitby.

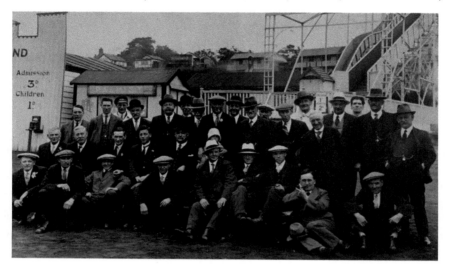

Party of Potteries People at Rudyard Lake, c. 1930
Our first picture does not feature the Potteries, but some of its people on a day trip to nearby Rudyard Lake which was known by some as the 'Blackpool of the Potteries'. There is a palmist's booth on the extreme left with fairground rides in the background. Jack Scott (1879–1947), the grandfather of John Scott, who donated the picture, attended this excursion. He was a thrower in the pottery industry, working at Royal Doulton in Burslem.

First published 2022

Amberley Publishing
The Hill, Stroud, Gloucestershire, GL5 4EP
www.amberley-books.com

Copyright © Mervyn Edwards, 2022

The right of Mervyn Edwards to be identified as the Author of this work has been asserted in accordance with the Copyrights, Designs and Patents Act 1988.

ISBN 978 1 3981 0048 0 (print)
ISBN 978 1 3981 0049 7 (ebook)

British Library Cataloguing in Publication Data.
A catalogue record for this book is available from the British Library.

Typesetting by SJmagic DESIGN SERVICES, India.
Printed in Great Britain.

Introduction

It is standard practice in works of this nature to present as many monochrome images as possible in order to highlight the differences between past and present. Perhaps this approach suits Stoke-on-Trent rather better than most conurbations as local industry did not merely give rise to a smoke-blackened environment. In the view of some, it created monochrome inhabitants. After all, wasn't it Harold Owen (*The Staffordshire Potter*, published 1901) who declared that 'The greatest advantage incidental to living in the Potteries is the hope of being able to make enough money to live out of it.'

The Potteries and its people have long been blackened in literature, and semantic contortions have been employed both to downplay the dehumanising bleakness of Stoke's past and, simultaneously, to praise its perverse beauty, its strange poetry.

The bottle ovens, pit headgears, spoil tips and dark canals depicted in this volume remind us of the manufacturing city that Stoke once was, and a fuliginous past that in the minds of many, branded it a blot on the landscape.

'It is only when you get a little further north, to the pottery towns and beyond,' wrote George Orwell in *The Road to Wigan Pier* (1937), 'that you begin to encounter the real ugliness of industrialism – an ugliness so frightful and so arresting that you are obliged, as it were, to come to terms with it.'

Perhaps Stoke's residents themselves become inured to the grind of industry and low wages – more than that, even strangely comforted by the predictable harshness of their world, like those victims of abuse who form a bond with their captors. However, it is a conundrum that despite the oppressiveness of life in Stoke, its people showed such resistance to change – as was remarked upon by the father of Tunstall-raised Paul Johnson (1928 to present), later a renowned historian.

'Change always brings losses,' wrote Paul, quoting his sire. 'The Potteries is hideous, dirty, wasteful and, I suppose, inefficient these days. But it's beautiful. Your mother doesn't see it. Nor do most people. But I do and you do, Little Paul. The French have a word for it, as they do for most things involving art – *jolie laide*. The Potteries is an ugly woman who has a strange kind of beauty. I shall be sorry when they kill her off.'

Yet photographs in this book illustrate the enormous strides that the city ultimately made to rid itself of its baneful reputation as 'Smoke-on-Stench': the reclamation schemes that transformed two colliery sites in Burslem and Hanley into Sneyd Hill Park and the glorious Central Forest Park; and the restored canal towpaths that permit walkers fascinating glimpses of the industrial sites that made Stoke its money and polluted its skies. Other images included in this project underline how vernacular architecture – houses and shops – have changed to meet the requirements of twenty-first-century society.

But it is not the identikit shopping facilities or the new office blocks that will adequately represent our legacy to future generations. In desperately trying to find a new USP, Stoke may yet find solutions in the murk of its industrial past.

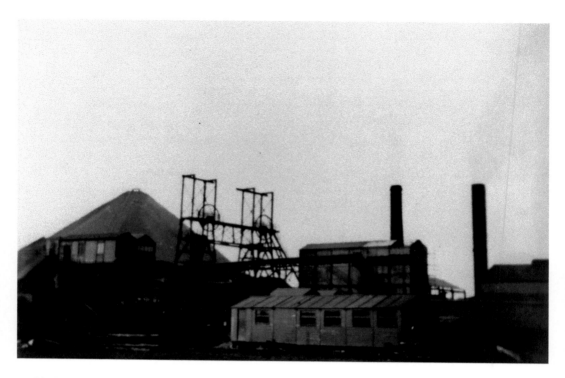

Parkhall Colliery, near Longton, date unknown

The Parkhall Colliery Male Voice Choir was formed in 1950, continuing as the Parkhall Male Voice Choir following closure of the pit in December 1962 and its waste tip was removed in 1972. Some miners achieved great longevity. John Stonier of Meir had worked underground at Parkhall for fifty-six years before retiring at the age of seventy in 1958. The site, situated at Weston Coyney, near Longton, was later occupied by the Cinderhill Industrial Estate.

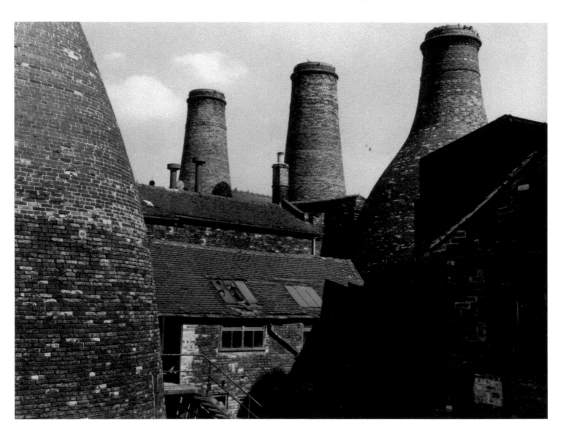

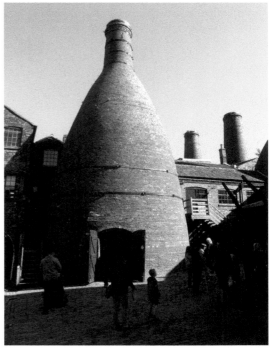

Courtyard, Gladstone Pottery Museum, Uttoxeter Road, Longton, *c.* 1971 and 2019

The Gladstone Works was saved from demolition in the nick of time, with bulldozers about to move on to the site in March, 1971. However, when manufacturers H. and R. Johnson Richards Tiles stepped in to buy the site, a Trust was formed and the plan launched to restore the works for future generations. The museum was opened for a trial period in 1974 and officially opened on 24 April 1975. It continues to exude everything that is best about Stoke-on-Trent.

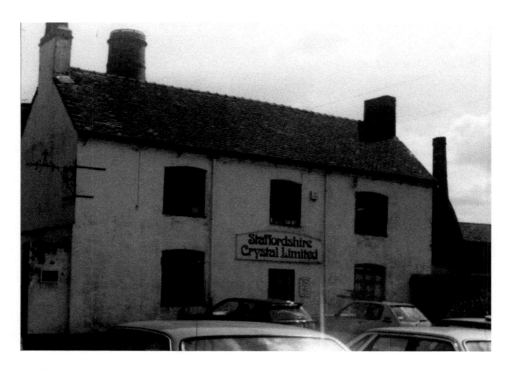

Staffordshire Crystal Ltd, Chadwick Street, Longton, 1990s, and The White House, 2019
This late eighteenth-century building is now part of the entrance to Gladstone Pottery Museum and known as the White House. It was Grade II listed on 15 March 1993. The Gladstone Works took its name from Victorian Liberal Prime Minister William Gladstone, though otherwise there is no connection between the two. The present museum site is regarded as one of the most important industrial heritage sites in Europe and employs skilled demonstration staff to explain traditional skills to visitors.

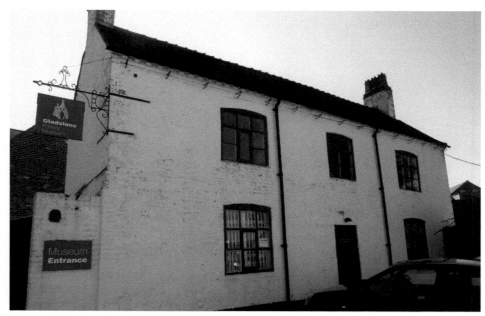

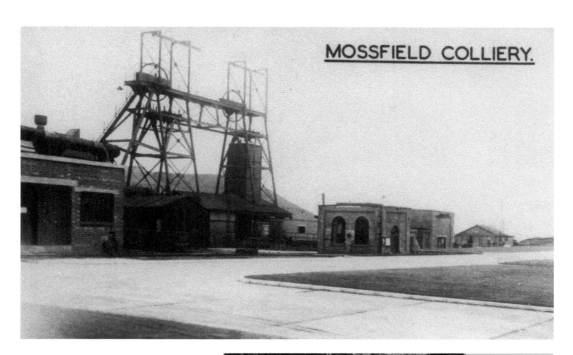

MOSSFIELD COLLIERY.

Mossfield Colliery, Longton, 1951, and Mossfield Colliery Disaster Memorial, Longton Cemetery, 2020

The colliery had four shafts and closed in May 1963. In October 1889, an explosion in the Banbury workings killed sixty-four men – thirty-seven in the Banbury workings and twenty-seven in the neighbouring Cockshead. A memorial to those killed can be found in Longton Cemetery. The pit was known by miners as the Old Sal – a name given in turn to a newly built pub in Heathcote Street, Sandford Hill, upon its opening in 1984.

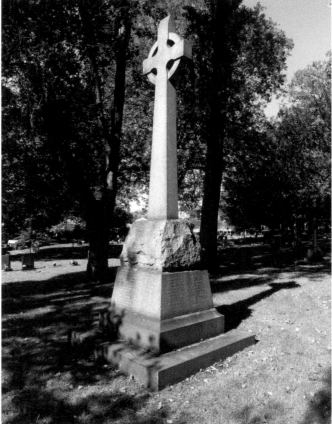

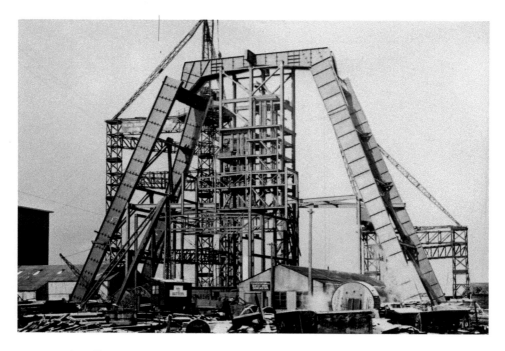

Hem Heath Colliery During Reconstruction, 1956, and Hem Heath Colliery A Frame, date unknown

This pit was sunk by the Stafford Coal and Iron Company at Great Fenton to exploit known extensive reserves of coal to the south of their Stafford Colliery. The first sod of the colliery was cut in 1924 by the Duke of Sutherland – the chairman of the company – and a shaft was sunk to the depth of 820 yards. Following Nationalisation, the plan was to increase the 1950 production figure of 243,632 tons to 1 ¼ million tons by 1963.

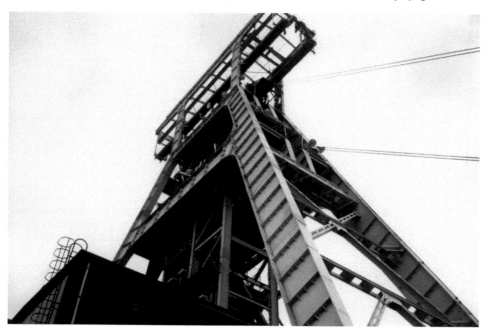

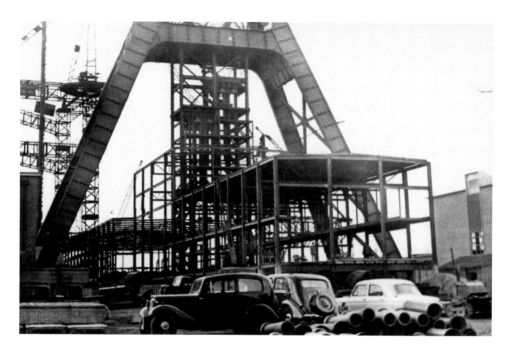

Hem Heath Colliery During Reconstruction, 1956, and Donna Louise Hospice, Trentham Lakes, 2013

A new shaft – the No. 2 as it was known – was sunk between 1950 and 1951 and became the third deepest in the country. It was 1,134 yards deep and 24 feet in diameter. This shaft became the downcast shaft and was carrying air into the workings in December 1953. It began to wind coal in August 1956. The No. 2 shaft 'A' type headgear became a prominent 180-foot-high landmark until the demolition of the colliery in 1997.

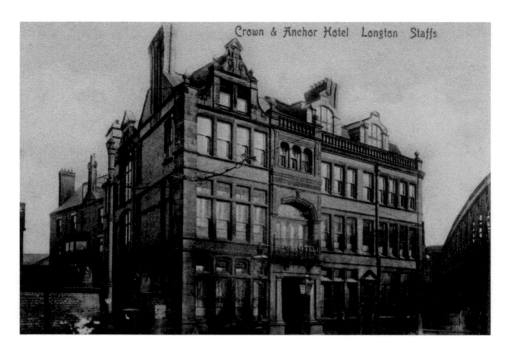

Crown and Anchor Hotel, Longton, Early Twentieth Century and 2014

This iconic hotel's recent fortunes contrast starkly with its magnificent past. It was grandly referred to in an 1818 trade directory as the Crown and Anchor Commercial and Coach Inn and was a popular venue around this time for multifarious functions. The United Pottery Lodge of freemasons were meeting at the hotel by 1815. When a new peal of eight bells was unveiled at the neighbouring St John's Church in 1816, a celebratory dinner was provided at the hotel, which was rebuilt in the 1880s.

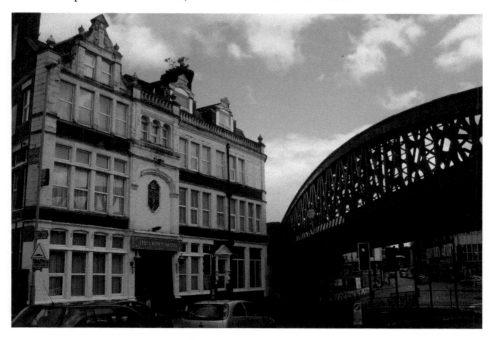

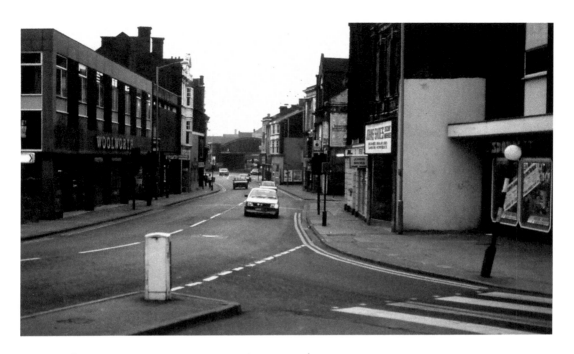

Market Street, Longton, c. 1970s and 2019

The original Woolworth's store in Longton opened in 1927 and a 1950s photograph displayed on the internet shows the Boot's store to its left in the days when Longton could offer some notable retail names. The store was rebuilt in the 1960s when the Bennett Precinct opened. In January 2020, *The Sentinel* newspaper reported that the old Woolworth's unit pictured here was one of only three former Woolworth's stores in the country that had not reopened since the retail giant collapsed in 2008.

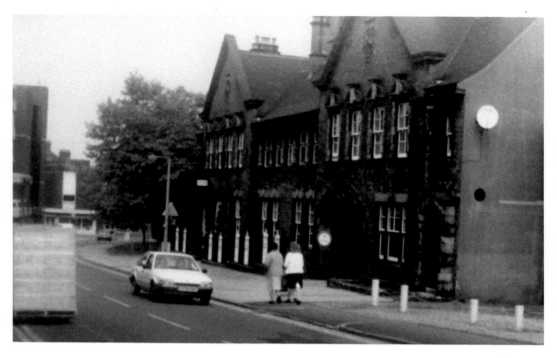

Police Station, Sutherland Road, Longton, 1990s and 2019

Longton's former police building was built in 1905 as brewery offices but was demolished in 1992 to make way for an all-new building that opened on the same site in 1994. The tower design was intended to offer a focal point in the Sutherland Road streetscape. It was announced in February 2019 that the cash-strapped Staffordshire Police Force was shutting reception desks at thirteen stations – but that Longton's was to retain its front desk, however.

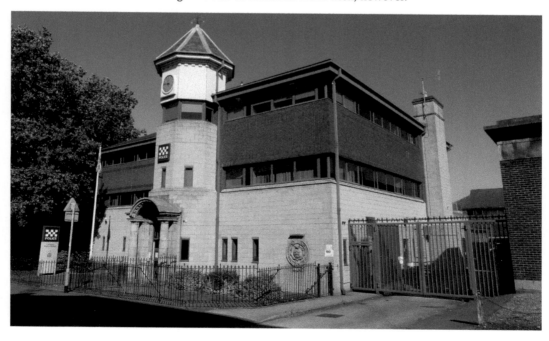

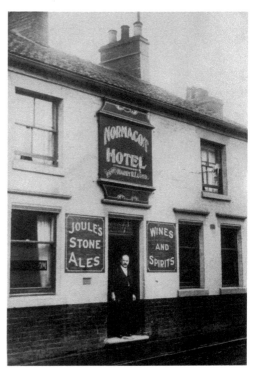

Normacot Hotel, Normacot Road, Normacot, date unknown, and Al-Madina Superstore, 2012

Our picture shows the Normacot Hotel prior to its rebuilding around 1938/40. Historian Alan Mansell states that the pub – with its quirky architecture – reopened on 12 January 1940. It was a Joules house at the time, and its chimney design should be compared to other Joules pubs of that era, such as the King's Arms in Meir (1935) and the Weston Coyney Arms (1939). It was taken over in 1973 by Bass brewery. Following closure, it reopened as an Asian supermarket in 2010.

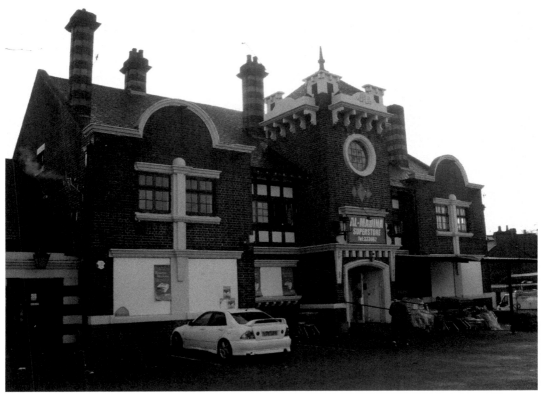

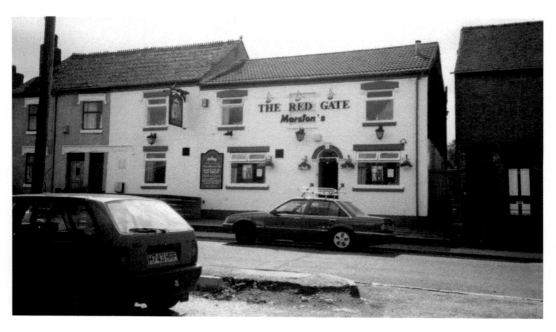

Red Gate Inn, Russell Street, Dresden, 1990s, and Potters Retreat, 2016

The former Old Red Gate and the Red Gate became the Potter's Retreat. It is not to be confused with another Red Gate Inn that once stood on the Trentham Road and which had associations with blood sports in the late eighteenth century. This pub appears to have originated as a beerhouse that opened up from a terraced house in the 1870s. *The Sentinel* announced in August 2019 that planning permission had been granted to convert the pub into living accommodation.

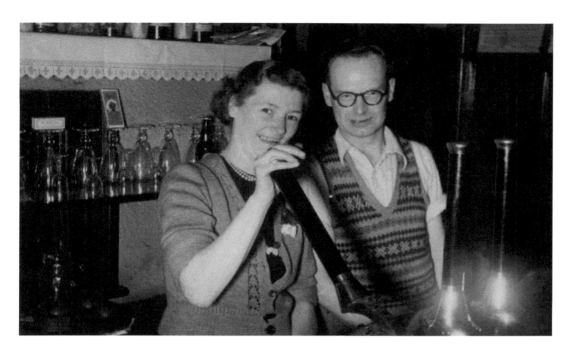

Sailor Boy, Uttoxeter Road, Longton, date unknown, and Pro Car Hire Ltd, 2019
Longton-based historian Alan Mansell records that the Sailor Boy appears on the 1856 OS map with an attached skittle alley and that it ceased trading on 20 July 1980. Colin Swift and wife Margery are pictured. Another local historian, Alan Myatt, writes that 'Margery had one day per week off and spent it at her friend's who kept The Rose Inn, further up Uttoxeter Road.' Margery (née Carr) was Alan's Mother's sister. The building survives, though no longer as a pub.

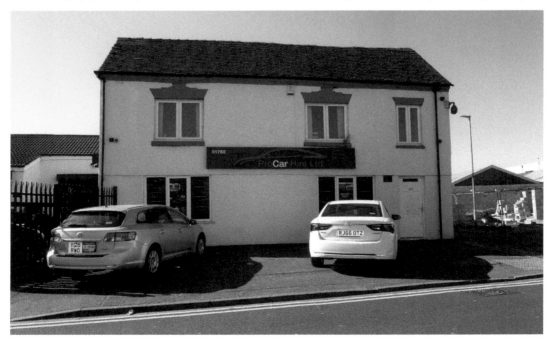

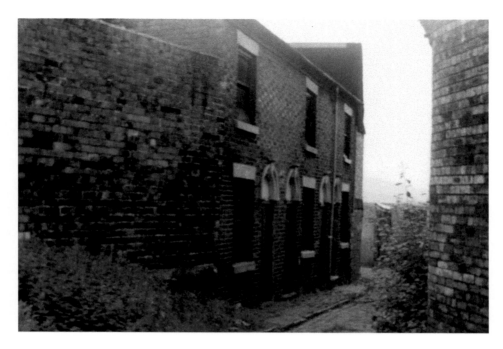

Short Street Cottages, Longton, 1991 and 2014

Echoes of Longton's past are to be found in the cobble-stoned Short Street, which connects Uttoxeter Road and Normacot Road. Here, red-brick homes, believed to have once been workers' cottages, have been Grade II listed and preserved as well as the adjacent Enson Works and its four bottle ovens. It is a conservation area that has been described by English Heritage as 'a unique townscape'. Historian Elise Turner is pictured in the more recent image.

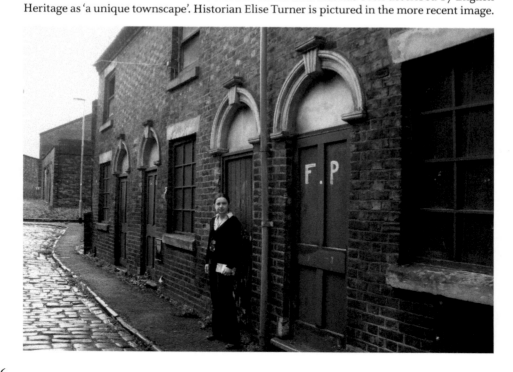

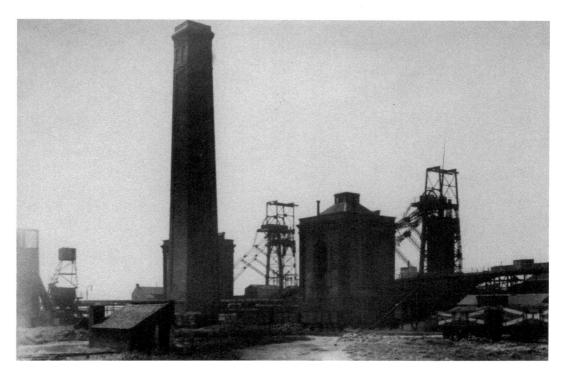

Stafford Colliery, Fenton, *c.* 1950, and Stoke City's Home Stadium, 2013
The Stafford Colliery, sunk in 1873, was often referred to as Stafford Coal and Iron, or Great Fenton Colliery, or Stafford No. 3 – Stafford No. 1 being Kemball Colliery. By 1962 *The Sentinel* reported that estimated coal reserves in the pit were still around the 40-million-ton mark, but by 1968 the colliery had only one operational face, closing in 1969. Stoke City's Bet 365 Stadium occupies part of the old site.

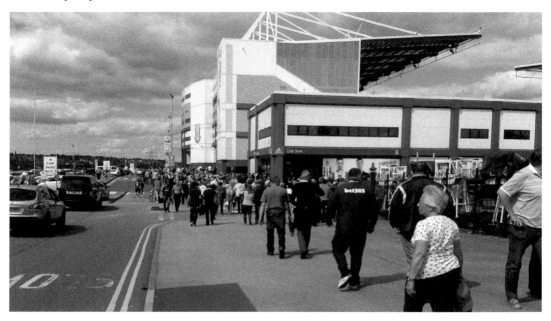

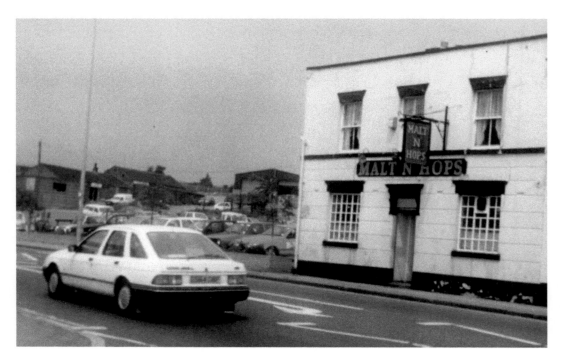

Malt and Hops, King Street, Fenton, 1990s and 2019

The Malt and Hops was formerly the Red House and was taken over by Len and Alice Turner in 1986. As the more recent photograph shows, the pub is still trading, but over the course of the past few years numerous Fenton hostelries have either closed down or been demolished including the Foley Arms, the Royal Oak, the Miners Arms and the Victoria.

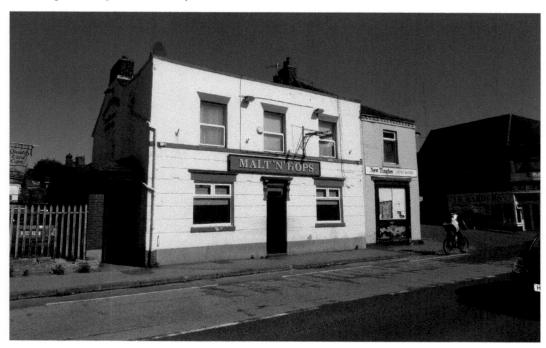

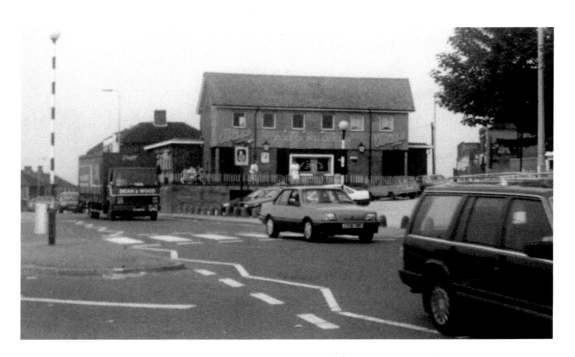

Duke of Wellington, King Street, Fenton, 1990s, and One Stop Convenience Store, 2020
This former pub building dates back to 1963 by Bass, Ratcliff and Gretton Ltd. It was built at a time when slum clearance was taking place across the city, and its site had previously been occupied by three old pubs and several dwelling houses that had been condemned by the local authority. Upon opening, its two rooms were the Potters' Bar and the Fenton Lounge. In 2017, the premises reopened as the One Stop Shop convenience store.

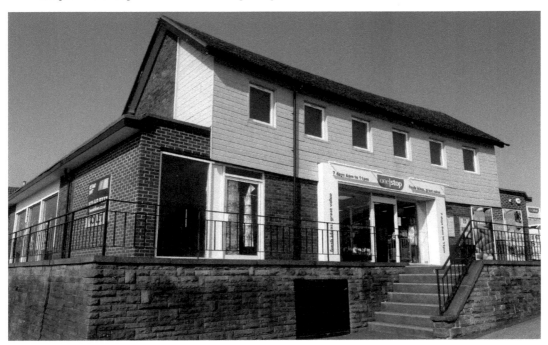

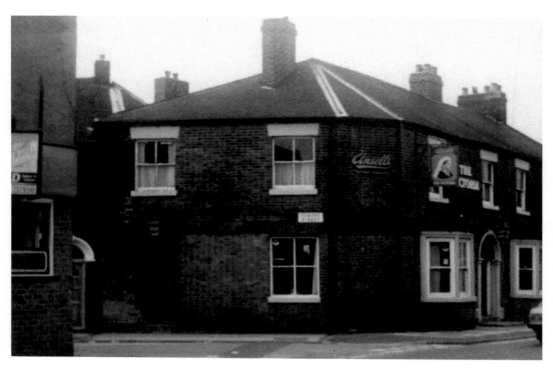

Victoria, Victoria Road, Fenton, 1990s, and Victoria Court Flats, 2020

In 1869, Joseph Hall applied for a licence for the Victoria Inn at Fenton Low. It was stated that it had been purpose-built as a public house, and that seventy-three houses had recently been built in the area. It quickly became a community hub, as intended, playing host to meetings of the Ancient Free Gardeners Friendly Society. It was renamed the Queen Victoria in 1993, but closed in recent years and in 2013, planning permission was given for conversion into flats.

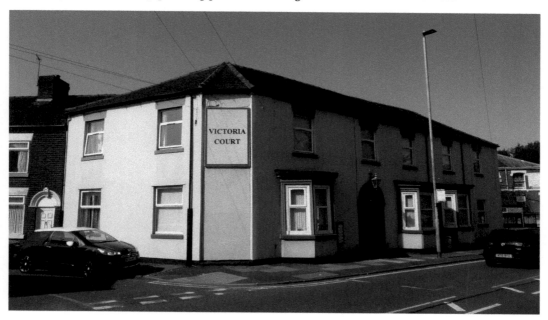

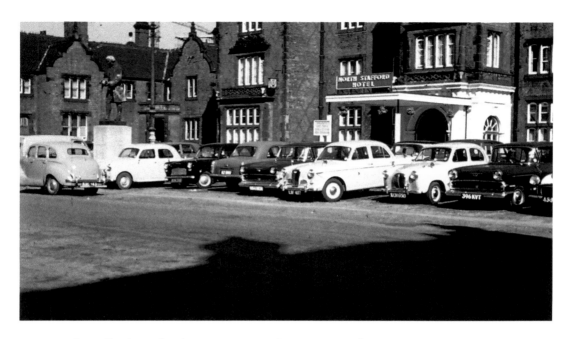

North Stafford Hotel, Winton Square, Stoke, c. 1960s and 2020

The North Staffordshire Railway Company's hotel, opened in 1849, was Arnold Bennett's fictional Five Towns Hotel. It appears in *The Dog* as 'the greatest hotel in North Staffordshire ... In the Five Towns it is august, imposing and unique'. Elsewhere, he wrote that 'by its sober grandeur and its excellent cooking, it had taken its place as the first hotel in the district. But its chief social use was perhaps as a retreat for men who were tired of a world inhabited by two sexes.'

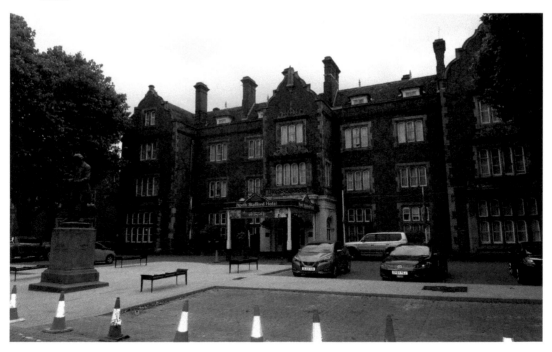

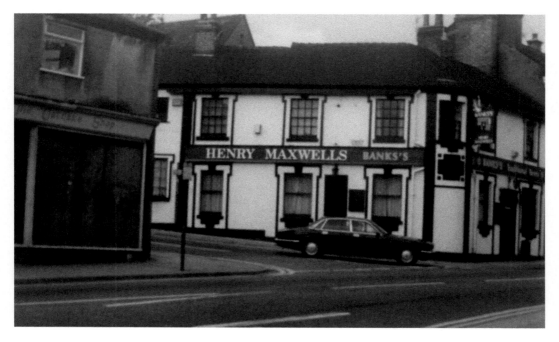

Henry Maxwell's, Hartshill Road, Stoke, 1990s, and Ye Olde Bull and Bush, 2020

The historic Sea Lion pub became Ye Olde Bull and Bush and – for a very short while – Henry Maxwell's before finding its feet as Gray's Corner. In the world of pubs, old names sometimes return, and this pub was reopened as Ye Olde Bull and Bush, on 16 October 2015 by landlord Rob Fiddaman. The main bar offered an excellent mural by artist David Light depicting various Stoke figures including Captain Smith of *Titanic* fame, Arnold Bennett and footballer Stanley Matthews.

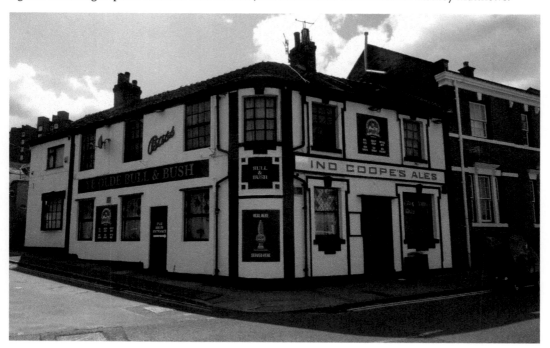

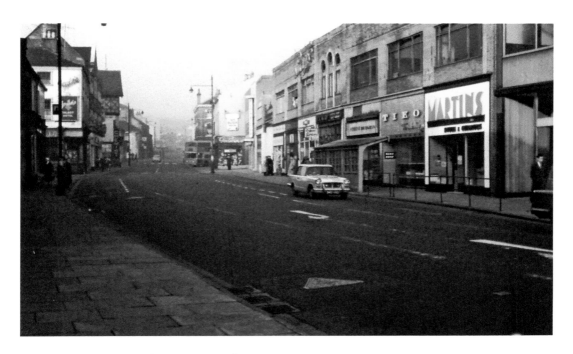

Church Street, Stoke, *c.* 1970s and 2020

The pub that appears on the left as we head towards Hartshill was historically the Talbot but disappointingly now trades as the Liquor Vaults. It was run between 1983 and 1993 by Hazel Nicklin, who died in 2007, at the age of sixty-four. She staged live music at the pub, allowing the well-known Stoke rock band Guns and Oatcakes to rehearse at the Talbot gratis. People may recall the pub's orange exterior colour scheme from the early 2000s.

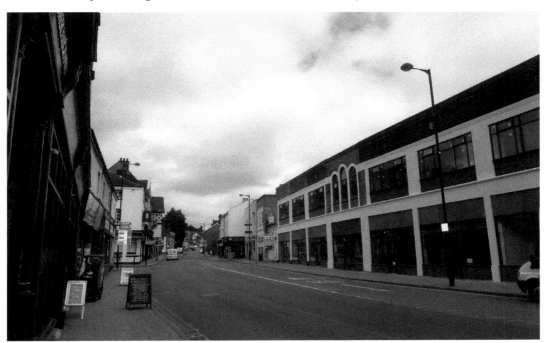

Radio Stoke Presenters: Sam Plank, 1999, and Terry Walsh, 2018
Photographer Derek Tamea's excellent study of Sam Plank (1948–2011) reminds us of the latter's contribution to the local media. Born in Middleport as Terry Hilton, he presented talk-based programmes and spoke in a broad Potteries accent. He was later given the Freedom of the City of Stoke-on-Trent and was a tireless fundraiser for charities and is remembered as a people's champion in the Potteries. Terry Walsh came to Stoke from Nottingham in 1974 and his much-loved programme embraces gardening and the great outdoors.

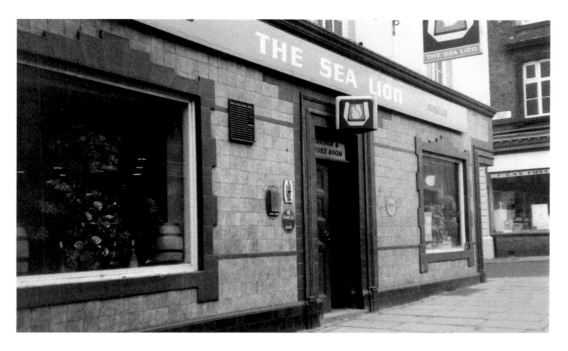

Sea Lion, Empson Street/Town Road, 1970s, and Intu Potteries Shopping Centre from Town Road, 2020

The pub had several historic associations with local amusement. In the nineteenth century, attractions from Batty's circus would sometimes appear on the pub's bowling green. Dramatic entertainment was provided on ground to the rear of the Sea Lion prior to the opening of the Theatre Royal in the 1850s. Field Marshall Tom Thumb, considered to be 'the most symmetrical dwarf in the world', appeared at the pub in 1846. It was demolished in 1980.

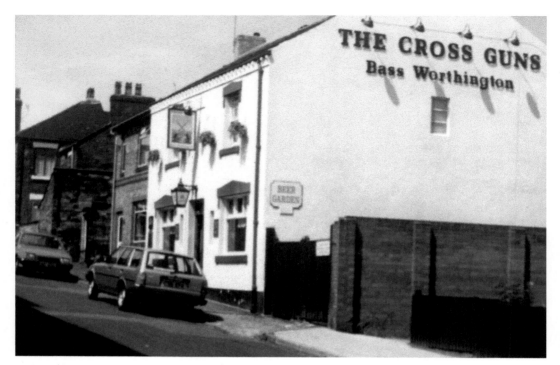

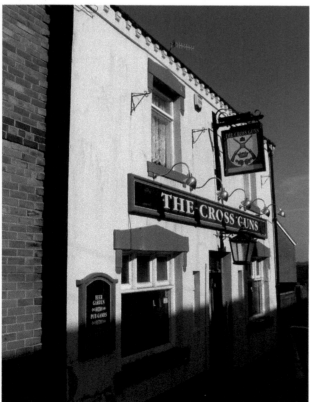

Cross Guns, Vincent Street, Northwood, 1990s and 2007
This classic backstreet boozer's front windows advertise the Parlour (left) and the Vaults (right) although later referred to as the lounge and the bar. In recent years, it has displayed framed Port Vale and Stoke City shirts signed by players, a photograph of Stoke City's 1972 League Cup-winning team, Ajax Amsterdam, Real Madrid and FC Barcelona football pennants. The lounge could boast of leatherette-upholstered bench seating and a brick-surround fireplace.

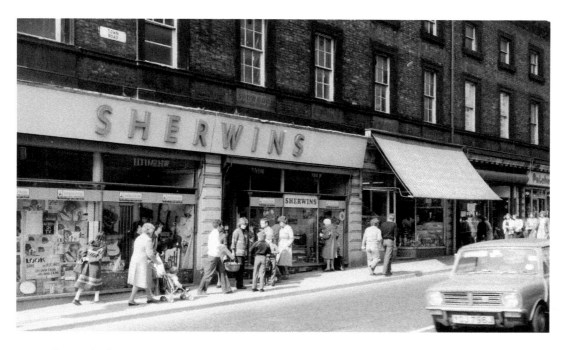

Sherwin's, from Town Road, Hanley, 1970s and Intu Potteries Shopping Centre, 2020
Sentinel contributor and local poet David Vickers well remembers this music shop and family business, as he worked there in the 1970s. He describes it as 'a shop with quite a bewildering selection of all things musical, where you could purchase anything from a guitar string to a grand piano' as well as a double-bass, a kazoo or a stylophone. It was finally demolished to make room for the Potteries Shopping Centre – now Intu Potteries – which opened in 1988.

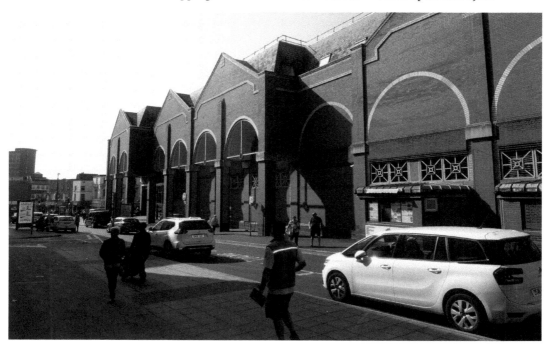

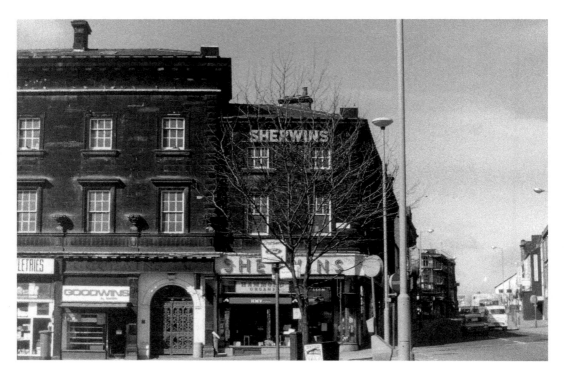

Sherwin's from Town Road, Hanley, 1970s, and Intu Potteries Shopping Centre, 2013
David Vickers recalls that the brothers Gilbert and Roy Sherwin were operating the shop in the 1970s. He remembers, 'Sherwin's was a deceptively large establishment, well remembered by many for its record department downstairs, with a line of listening booths similar to telephone boxes, where you could audition the latest records on headphones, and in theory, purchase them.' In practice, however, the boxes became a popular gathering place for teenagers wanting to listen to the latest chart singles.

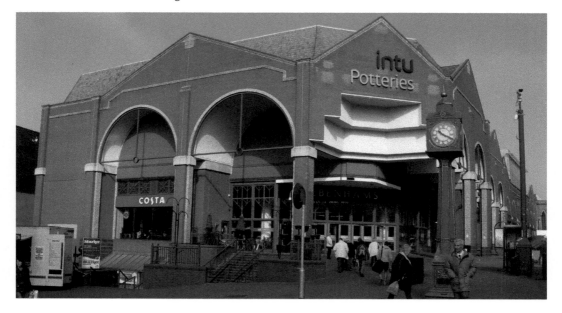

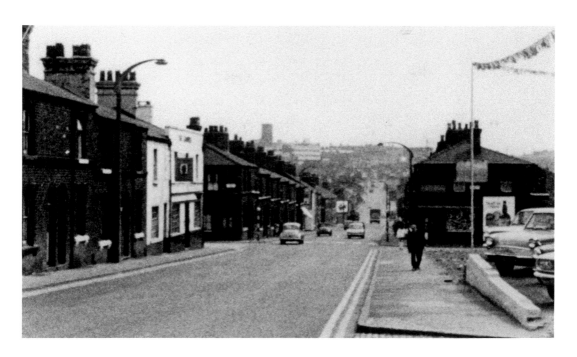

Waterloo Road, Hanley, 1969 and 1992

The picture looks towards Vale Place and Hanley, with St John's Church on Town Road visible in the distance. Waterloo Road was built between 1815 and 1817, commemorating the 1815 battle in which Wellington beat Napoleon. However, the southern end of it – seen here – already existed in 1814. The driveway in the right foreground appears in both of these photographs. Further along the road on the right, travelling to Hanley, was the Railway Tavern at Vale Place, demolished in 2000.

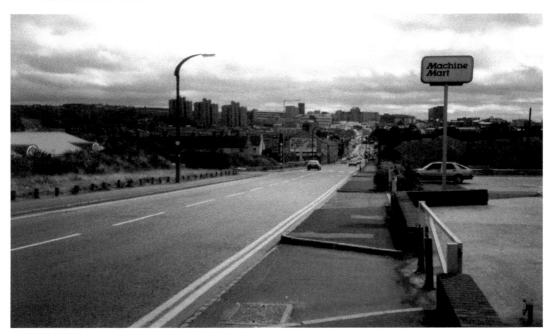

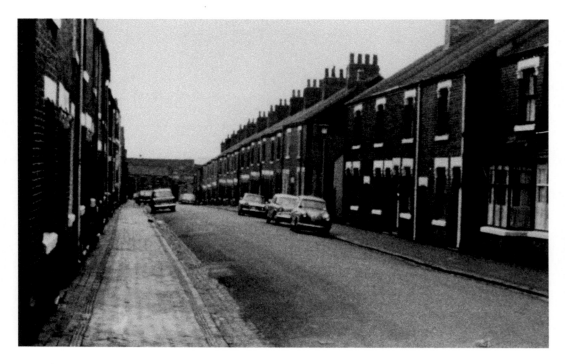

Boundary Street, Hanley, 1969 and 1992

These photographs were taken from the corner of Boundary Street and Lower Bryan Street. In the monochrome picture, there is a lamp standard on the right. The opening, just behind it, is the entrance to the Brookfield brickyard. At the end of the street is the Potteries bus garage at Vale Place. In front of it is the carpenter's shop at Howlett's builder's yard. Boundary Street survives, but is now in two sections extending to Waterloo Road.

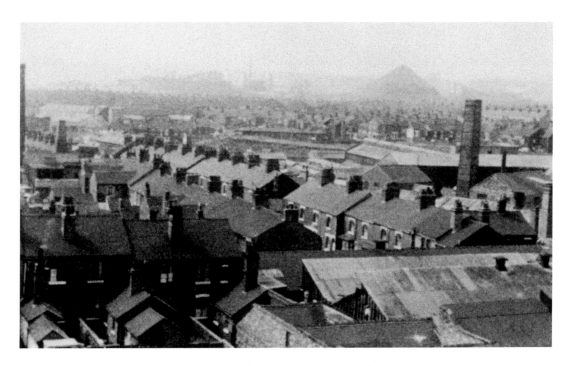

Boundary Street and Vale Place, Hanley, 1969, and Same View, 1992
The picture was taken from the lower slopes of the spoil tip belonging to Deep Pit – now the site of Central Forest Park. Boundary Street – with the bay windows – is in the lower right of the photo. The roof at lower right is that of the Brookfield Foundry. The Brookfield Brickworks embrace the tall chimney on the right. The long building with the round roof vents, running parallel to Boundary Street, is another foundry, part of the Brookfield Foundry.

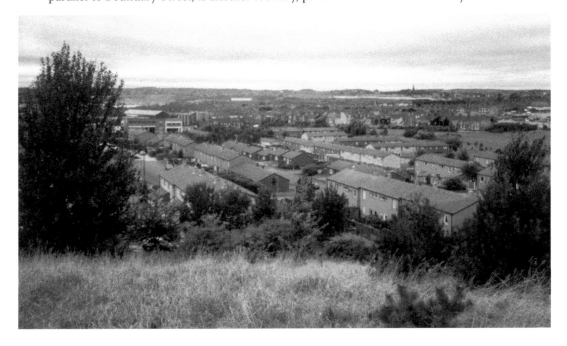

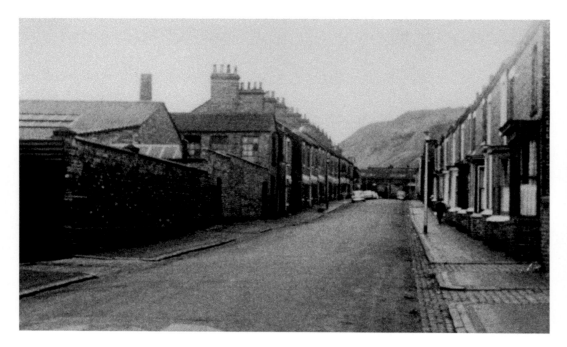

Boundary Street, Hanley, 1969, and Same View, 1992
The monochrome picture was taken from the corner of Boundary Street and Malam Street and shows the old spoil tip still in situ. In front of it is the Brookfield Foundry, which manufactured cast-iron gutters and downspouts, etc. The gate on the lower left of the picture is the entrance to Howlett's builder's yard and the building with the skylights was the mill, which housed woodworking machinery including a large crosscut on the first floor that sliced tree trunks into boards.

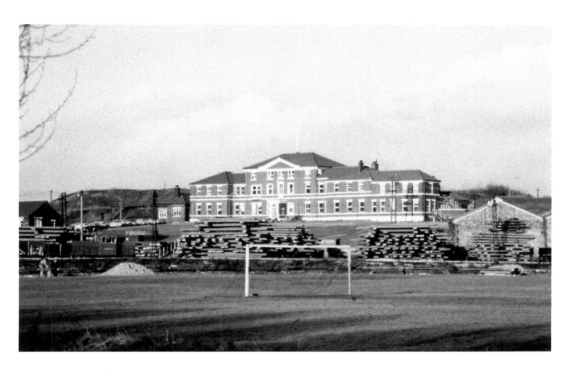

Etruria Hall, date unknown and 2020

Etruria Hall was built for the Wedgwood family, who moved into the property on 11 November 1769, nearly six months after Josiah's factory, the Etruria Works, had opened. Etruria Hall was originally built with three stories and five bays, having wings added in the 1780s. There were many paintings in the hall, including a Wedgwood family group, completed around 1780 by George Stubbs, depicting the leafy splendour of the hall grounds at this period. The hall is now part of the Moat House Hotel.

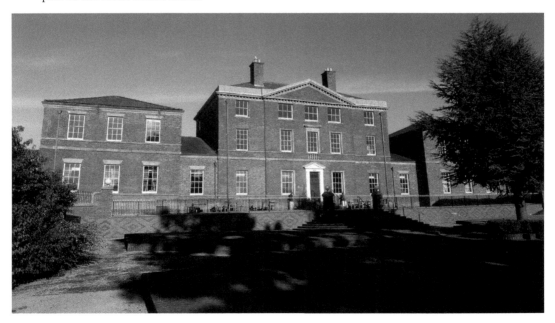

Brookfield Foundry, Cobridge, and Sneyd Street, 1969, and View of Cobridge and Sneyd Street, 1992

The picture was taken from the lower slopes of the pit tip, now landscaped and part of Central Forest Park. In the foreground is the Brookfield Foundry and adjacent blast furnace. Beyond is the marl pit used by the Brookfield Brickworks. The part on the right is fenced with old railway sleepers. The same view in 1992 shows a football pitch on the left and houses in Kibworth Grove and Lower Bryan Street on the old foundry site.

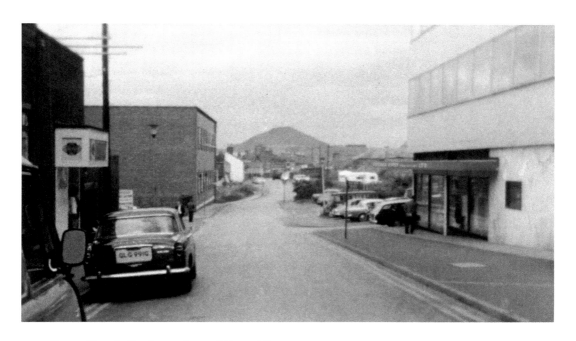

Bryan Street, Hanley, 1969, and Same View, 1992

The Place in Bryan Street, Hanley (left), opened 1963, converted from an old warehouse by a company called MSV Enterprises (Hanley) Ltd. The Place aimed to provide a full evening's entertainment for the 18–40 age group, believing that teenagers were adequately catered for at other venues. Annual membership fee was 10s. 6d. It offered 'Twist, Madison, Latin American and Slow Tempo' music and proudly announced that 'Canister Worthington E' was on sale. Following many vicissitudes, the venue was demolished in 2015.

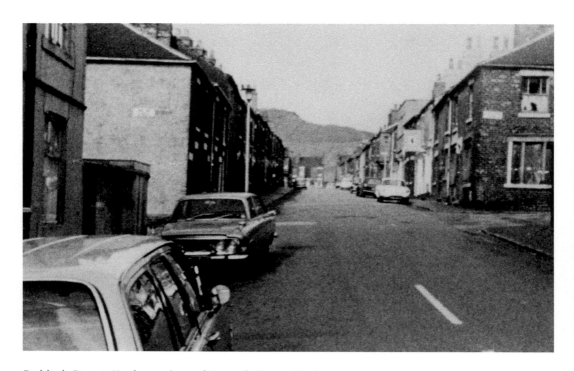

Paddock Street, Hanley, 1969, and Penarth Grove, Hanley, 1992
The photo was taken from the corner of Paddock Street and Waterloo Road. At the far end was a cross-street, Lower Bryan Street, and beyond is Deep Pit spoil tip. The nearer streets to the left and right are Malam Street and Gower Street. St Chad's Church was a notable feature of Paddock Street. The later picture was taken from the corner of Penarth Grove and Malam Street, which now extends to Union Street.

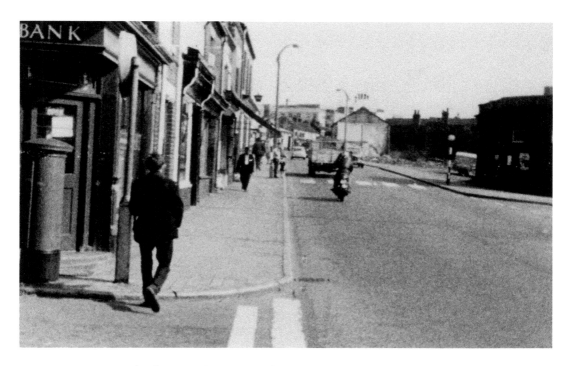

Hope Street, Vale Place, Hanley, 1969 and 1994

The photographer was standing at the corner of Paddock Street and Hope Street at Vale Place. A post office is to the immediate left. The structure on the right near to the Belisha beacon was a men's toilet. The derelict ground just above was the site of a row of houses until the 1960s. The later view shows the Potteries Way as the first road on the left in a radically changed pocket of Hanley. The bottle oven belongs to the Dudson Pottery site.

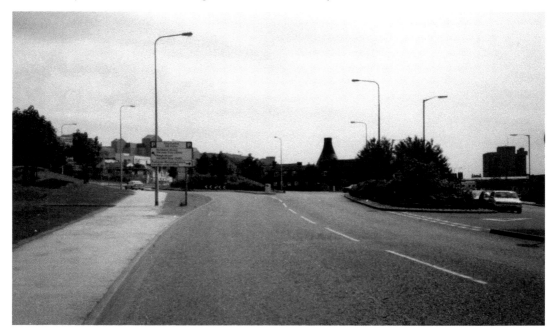

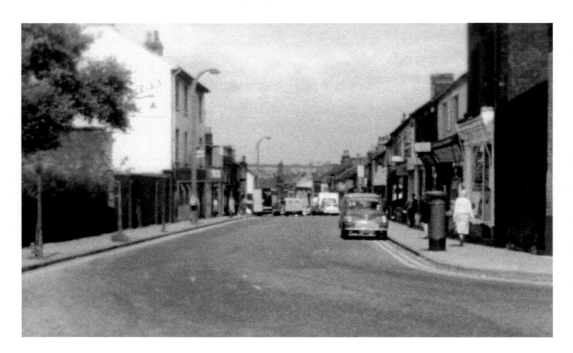

Hope Street, Hanley, 1969, and Same View, 1992

The large pub on the left was the Borough Exchange. A trade directory of 1892 advertises that it was then kept by Sarah Dawson, wine and spirit merchant, who was selling Bass's Entire. It became the Queen and Crumpet in 1997 and has had other names since. Among the shops that are remembered in Hope Street are Chawner's pawnbroker's shop and Chatfield's music shop. Among the other shops that have sold music equipment in Hope Street is the long-established Kay's, which still trades today.

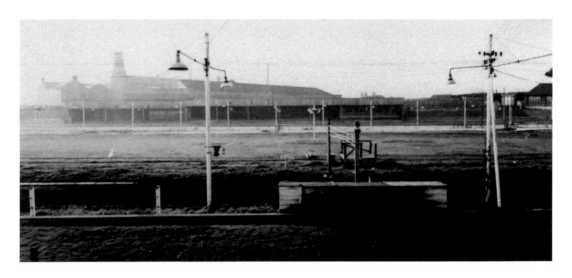

Sun Street Stadium, Hanley, View towards Directors' Stand, date unknown, and Perimeter Wall, 1995 (now demolished)

Speedway racing began at Sun Street Stadium in 1939 but was ended with the outbreak of the Second World War. It returned in 1947. A nearby ash tip overlooked the stadium and crowds often watched the sport free of charge from this popular vantage point, leading to its being known locally as Scotchman's Hill. Around 1953, the promoters withdrew and the stadium remained unused until around 1960 when new backing was secured. It lasted until 1963 when the stadium was again put up for sale.

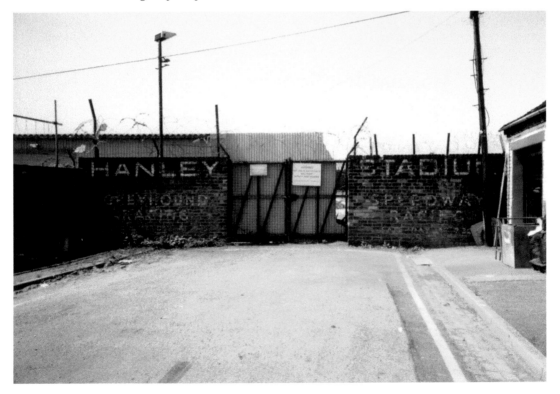

Lower Bryan Street, Hanley, 1969, and Same View, 1992
This picture was taken from the corner of Boundary Street and Lower Bryan Street. The rectangular building to the left is the Brookfield Foundry. The street leading off to the right in the middle distance is Paddock Street. At its near corner was a general store that sold various goods including bread, cigarettes and firewood. The later picture shows Boundary Street on the right with, centre-right, Rixdale Close, a remnant of the former Paddock Street.

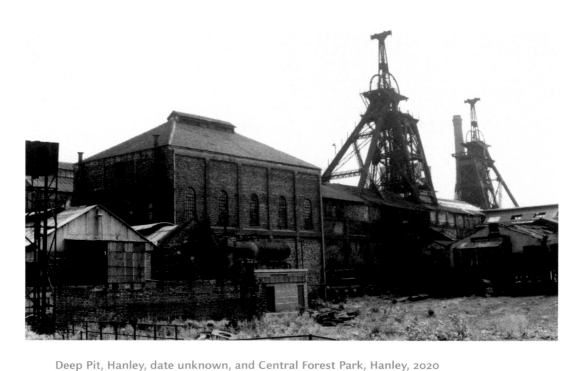

Deep Pit, Hanley, date unknown, and Central Forest Park, Hanley, 2020

Deep Pit, Hanley, finally closed in 1962 and the site was reclaimed to become Central Forest Park, opened in 1973. However, the pit had a multifaceted history. In the nineteenth century, rough-and-ready miners sometimes engaged in prize-fights – such as one that occurred behind the pit in 1883. Collier Thomas O'Donnell was furiously fighting another man before an audience of around 100 people before the bout was broken up by police. O'Donnell was sentenced to fourteen days in prison with hard labour.

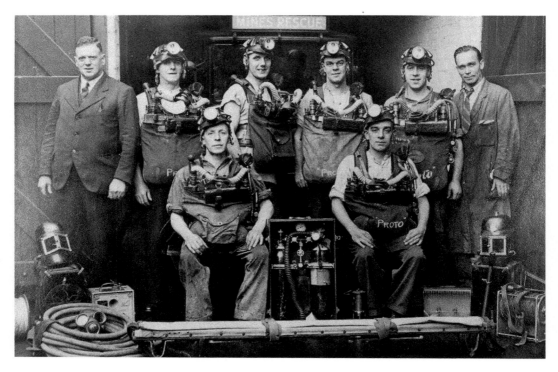

Deep Pit Rescue Team, 1948, and Central Forest Park, Hanley, 2020
Fred Clarke is seen seated, left, and Albert Edward Dobell is standing second from the right next to the man in an overall. Albert – born in 1912 – had been living at Burslem and working at Sneyd Colliery when a disaster occurred there in 1942 killing fifty-seven men. He worked at several other pits including Florence, finally leaving the mining industry in the 1950s after being diagnosed with severe pneumoconiosis. This information comes from Hilary Whalley (née Dobell).

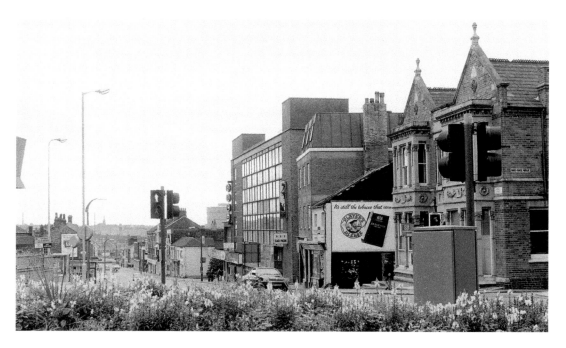

Top of Broad Street, Hanley, 1970s, and Same View, 2020

The ABC Cine-bowl, seen in this picture, opened in 1963, with *The Cracksman* starring Charlie Drake. One of the inconveniences experienced by customers of other cinemas at the time was alluded to by *The Sentinel*, which remarked that 'the effective air conditioning ensures that vision will never be impaired by tobacco fumes'. It swiftly became a pioneering multiplex in Stoke-on-Trent, offering a cinema, bowling alley, and dance floor-cum-skating rink all in the same building. It closed in 2000 and was demolished in 2007–2008.

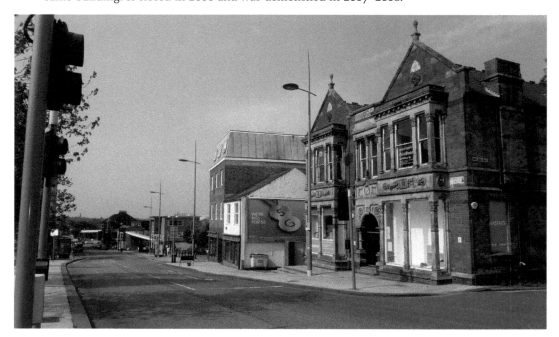

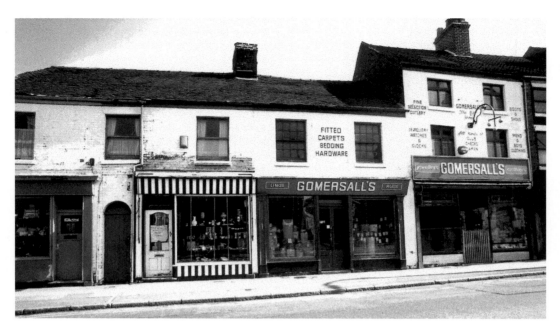

Gomersall's, Broad Street, Hanley, 1970s, and Lower Broad Street, 2020

Richard Weir, writing in his 1988 book *Six of the Best*, scribed that Horace Gomersall opened two pawnshops in Hanley in 1906 – this being one of them. Pawnshops in those days usually had a sale shop where items not collected after a designated time could be sold off. Gomersall's shop often saw long queues outside. Gomersall's closed on 2 August 1986 according to Mr Weir. Major redevelopment took place at the foot of Broad Street in order to accommodate the Potteries Way road.

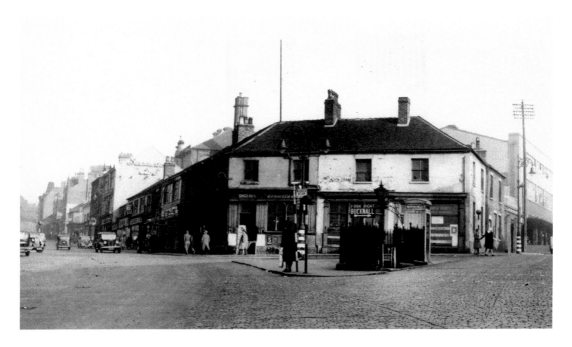

Piccadilly, Hanley, 1945, and Same View, 2020

Near the extreme left of the earlier photograph we see the vertical sign advertising the Regent, which opened as a cinema in 1929. It was renamed the Gaumont in 1950 and the Odeon in 1976 and is now the Regent Theatre, run by the Ambassador Theatre Group. To the right of the picture is an art deco building in Albion Street once known as Pepper's Garage and in more recent years styled Minh's oriental buffet restaurant and bar.

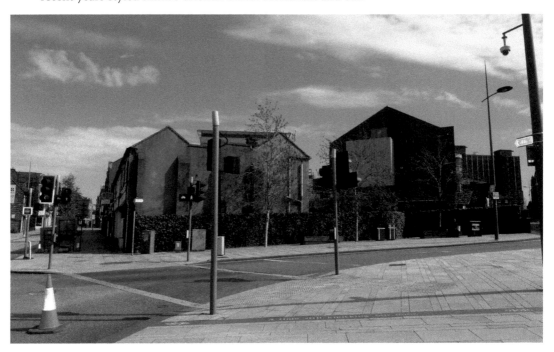

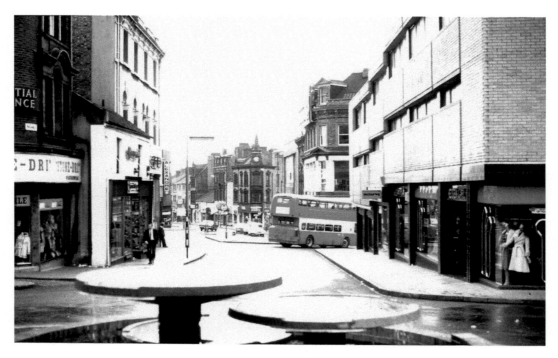

Piccadilly, Hanley, 1970s, and Same View, 2020

In 2017, the public toilets were removed in nearby Crown Bank on account of their being a magnet for antisocial behaviour. It is nothing new. In 1885, the mayor said that Piccadilly 'was almost impassable on Sunday night, notwithstanding the heavy rain', through the gathering of young ruffians. Magistrates' Clerk Mr Hamshaw added that 'it was difficult to go along the thoroughfare without being in some way annoyed. The police were ordered to keep a strict watch in the street.'

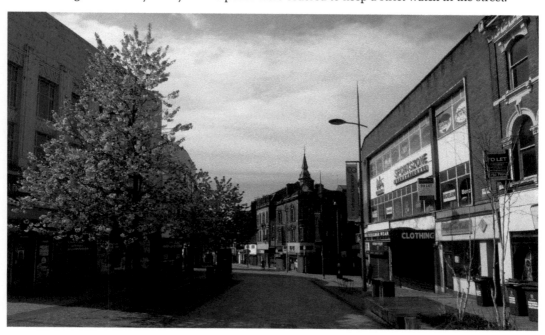

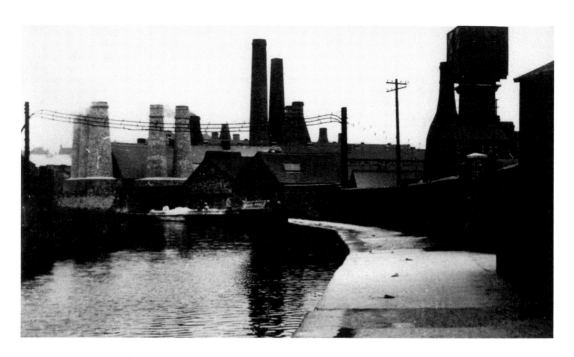

Scene on Caldon Canal passing through Hanley, 1957 and 2020

Both old and new images show how industry clung to the towpaths of the Caldon Canal. Built as a branch of the Trent and Mersey Canal, it is 17 miles long and runs from Etruria to Froghall, having been opened in the late 1770s. It mainly carried limestone from the Caldon Low quarries and some coal from the Cheadle coalfield. In much later times, Johnson Brothers' specially built barges – named the *Milton Maid*, the *Milton Princess* and the *Milton Queen* – carried pottery along this canal.

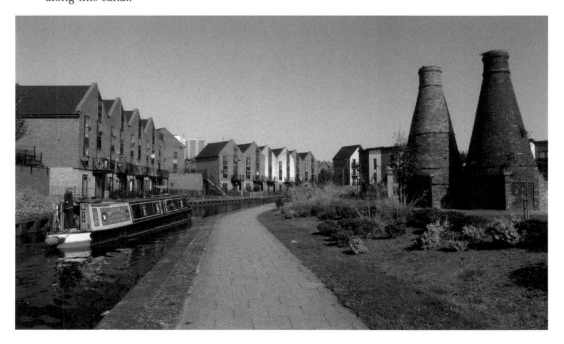

Five Towns Café, Hope Street, Hanley, date unknown, and Hope Street, Now Redeveloped, 2020

This location marks the spot where Potteries writer Arnold Bennett was born on 27 May 1867; however, the property that witnessed his birth – and which later became a pie shop – was demolished in 1961 and replaced with a café whose name doffed its cap to the author of the *Five Towns* novels. The cafe was demolished in 2003 and in 2008 a new hostel for the homeless was constructed on the site, on the corner of Hope Street and Hanover Street.

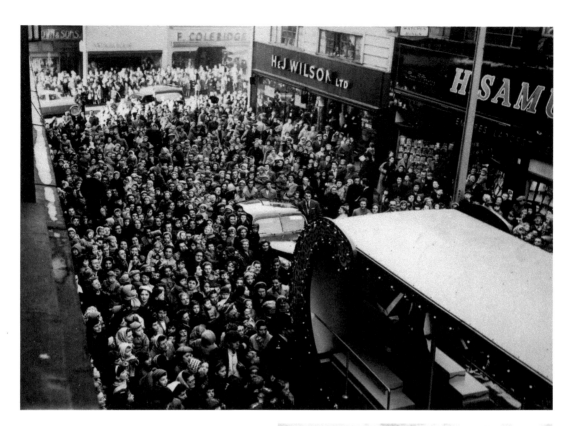

Lewis's, Hanley, 1958 and *Man of Fire*, 2020

The Liverpool firm of Lewis's took over the former McIlroy's department store in 1935 with 350 employees, most of whom were retained in the takeover. There was major reconstruction in the early 1960s. The first stage of the building officially was opened in 1962 incorporating the Food Hall, with its twenty-seven refrigerated counters and the Hairdressing Salon. In 1963, the new Lewis's formally opened – described as 'the country's most up-to-date store'. It incorporated the Staffordshire Knot Restaurant, which could accommodate 240 people.

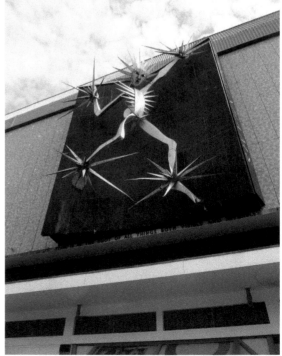

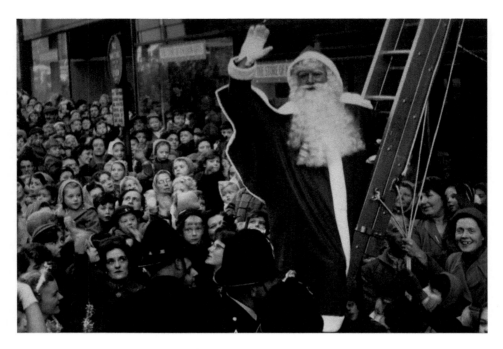

Lewis's, Hanley, 1958, with Santa Claus, and Shops in Same Location, 2020
The *Man of Fire* sculpture was erected on the Stafford Street side of the premises and this survives today, bearing the inscription 'Fire is at the root of all things both visible and invisible'. It was sculpted by David Wynne, who was inspired by the fires of the bottle ovens that had once reigned in the Potteries. Lewis's became part of the Potteries Shopping Centre, opened in 1988. In 1998, Lewis's was taken over by Owen and Owen and the store reopened as Debenhams.

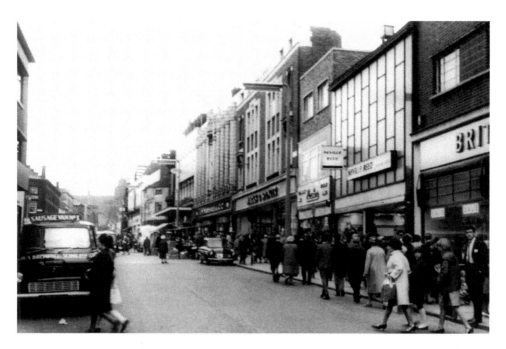

Parliament Row, Hanley, date unknown, and Same View, 2020

The conspicuous shop in the photograph is the Marks and Spencer Ltd store. The firm originated in Leeds in 1884, but its first store in Hanley opened at No. 33 Piccadilly, in 1908. The move to Nos 11–13 Upper Market Square came as the company quit the small-shop image to become a major retailer with an emphasis on clothing and fashion. The store was opened in July 1934 and sold nothing over five shillings. It was enlarged in 1973.

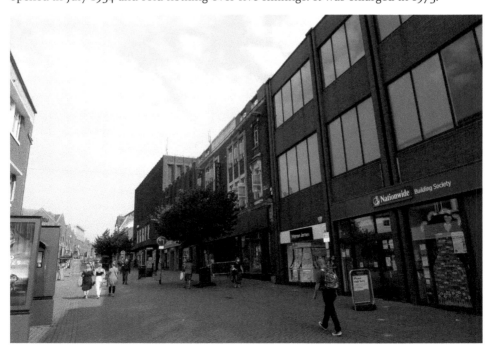

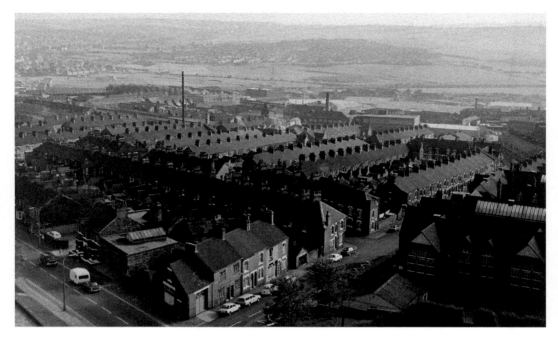

Wellington Road, Hanley, 1970s, and Schools, Wellington Road, 2012
School buildings dominate the above photograph. Stoke City and England's Sir Stanley Matthews (1915–2000) attended Wellington Road School between 1920 and 1929 and it was there where he first played football. The school later came to organise an annual Sir Stanley Matthews Day each spring and unveiled a plaque in his honour. The pub at the far end of Wellington Road was the Highland Laddie, demolished in 2011. Its frontage incorporated a pediment embracing a Parker's Ales motif.

Hammersley Fountain, Hanley Park, 1953 – Gillian Carp (née Rawlins) in Photograph, and Restored Fountain, 2017

Hanley's 62-acre park was bestowed with many items of park furniture by the great and good. The terracotta fountain in the Caldon Grounds was donated by Ald. Hammersley in 1894. The water was not turned on until 1896, when the four ornamental dragons were added. They were modelled by Rowland Morris, who is remembered for his work on the façade of the Wedgwood Memorial Institute in Burslem – and made by W. T. Copeland & Sons in Stoke.

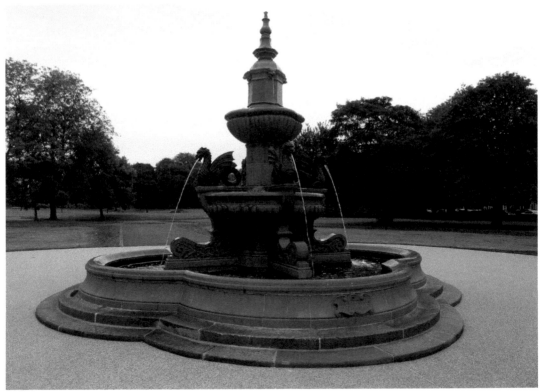

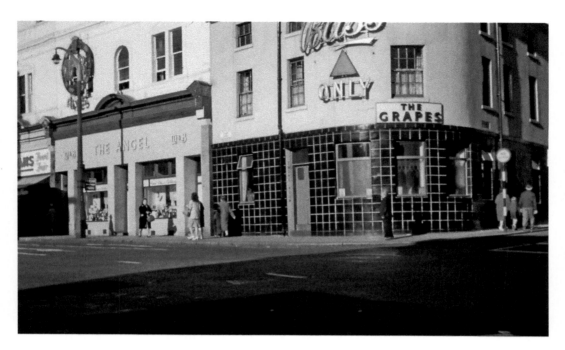

Angel Hotel and Grapes, Market Square, Hanley, c. 1960s, and Co-operative Bank, 2020

The Angel was one of the most glorious hotels in Hanley, its new assembly rooms being opened in 1878. In August 1971, *The Evening Sentinel* newspaper included a photograph of demolition workers perched on the roof of the Angel and the Grapes – which was nicknamed Wilders. 'They will be replaced by a shopping development and a basement public house,' ran the article. The pub was the Roman Candle, opened in 1973, but a remnant of the Angel somehow survived and now incorporates Santander.

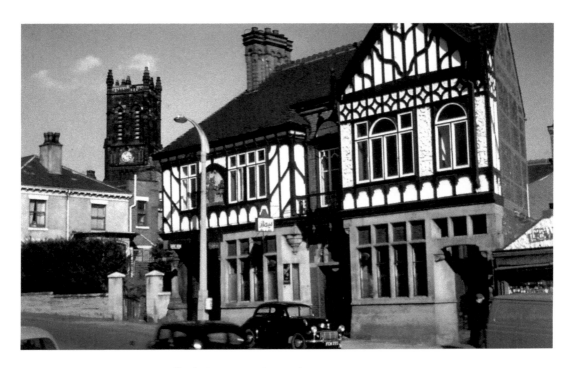

Bell and Bear, Snow Hill, Shelton, *c.* 1960s and 2020

Many people gaze at the derelict Bell and Bear and assume from its architecture that it must be a very old pub. However, above the door fanlight is the date when it was rebuilt: 1892. It is a mock-Tudor building, advertised in Keates' Directory of 1892-3 as being the 'first calling house from Stoke to Hanley, and nearest house to New Park'. The pub was certainly ahead of the game, as the first part of Hanley Park did not officially open until 1894.

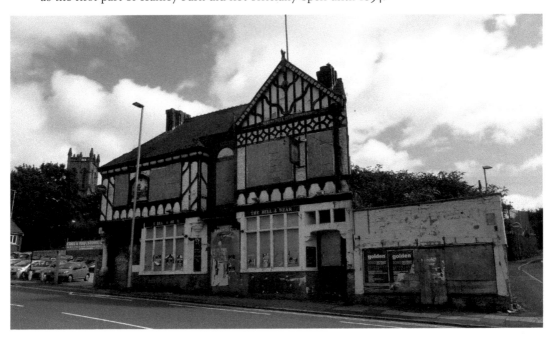

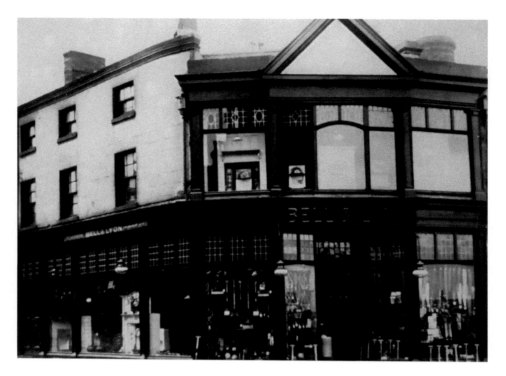

Bell and Lyon, Market Place, Burslem, date unknown, and India Cottage Restaurant, 2020
A trade directory of 1893 lists Messrs Bell and Lyon, General and Furnishing Ironmongers, at No. 6 Liverpool Road – the present Westport Road. By this time, they had been operating for sixteen years as a general ironmongers and also sold joiner's and other tools, grates and chimney pieces, Sheffield cutlery, travelling trunks, oil stoves, lamps and gas fittings and even cricketing equipment. Many items were made at workshops in nearby Packhorse Lane.

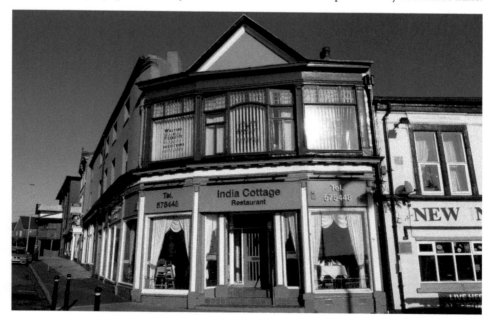

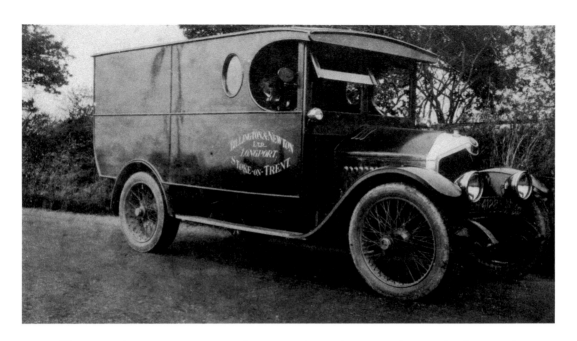

Billington and Newton, Longport, Delivery Van, date unknown, and Original Vulcan Works, 2020
The original Billington and Newton brass foundry stood on the corner of Canal Street and Bradwell Street and is the building on the right of the recent photograph. The firm was established *c.* 1870, employing 200 people by 1914. The company made such diverse items as manganese bronze propellers and colliers' blasting tools. It also made the two shields (dated 1929) on the gates of Tunstall's Memorial Gardens. The firm was amalgamated with T. M. Birkett and Sons in 1948.

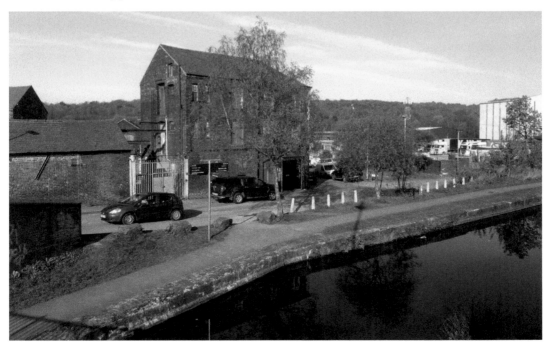

Billington and Newton, Longport, date unknown, and Gates to Former Vulcan Works, 2020
Charles Billington (*c.* 1836–1902) was the director of a small business at Chatterley Bridge, Hanley, before he came to partner John Newton. Their business was moved to land near the Packhorse Hotel in Longport that had been purchased from Fred Bowers by Newton. Both Charles and John lived in Woodland Avenue, Wolstanton. Newton died in 1929 being by then the senior partner and chairman of Billington and Newton. He was eighty-six years old.

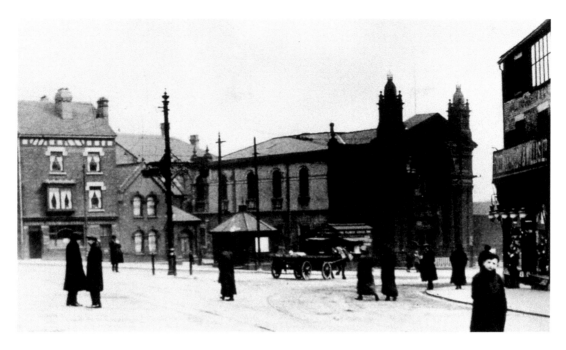

Swan Bank, Burslem, date unknown, and Same View, 2020

The imperious Swan Bank Methodist church, dominating this photograph, was demolished in 1970 and an excavation was carried out on-site. The lower levels of the archaeological dig produced the first evidence of medieval occupation in the town. Also found were pieces of medieval pottery, some of which was thought to have come from the medieval kilns at Sneyd Green. Later pottery was also discovered. The opening services and dedication of the rebuilt Burslem Methodist Central Mission took place on 15 May 1971.

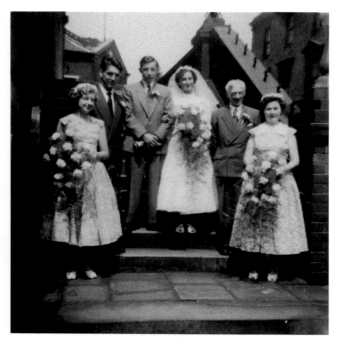

Hill Top Methodist Chapel and Sunday School Portico, Westport Road, Burslem, date unknown, and Portico, 2020 Elements of three interesting buildings are seen in the monochrome photograph. The wedding party is standing on the steps below the frontage and colonnade of the Hill Top Methodist Church, opened in 1837 in what is now Westport Road. In the background is the Wade Heath factory, formerly the Hill Works and built in 1814. Alcock's Hill Top Works was still standing, opposite the chapel, when this picture was taken but was demolished in the 1960s.

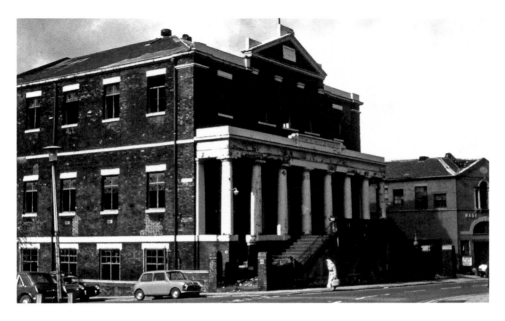

Hill Top Methodist Chapel and Sunday School, Burslem, *c.* 1960s, and Same View with Only Portico Remaining, 2020

The opening of this building in 1837 occurred following a heated dispute between the Wesleyan preachers and trustees of the Swan Bank Methodist Church and the teachers and managers of its Sunday school – who were cast out by the Church. Their response was emphatic, as indicated by this vast building, a monument to the march of intellectual freedom. 7,000 people attended its foundation stone laying in 1836. The schoolrooms occupied the basement storey and the galleried chapel the upper storey.

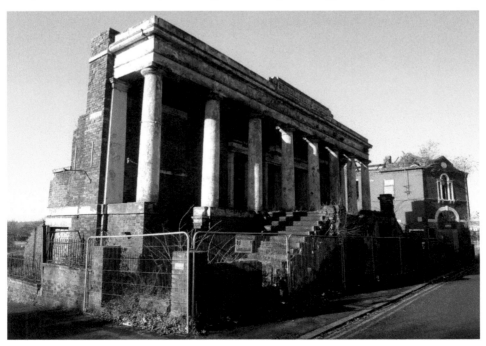

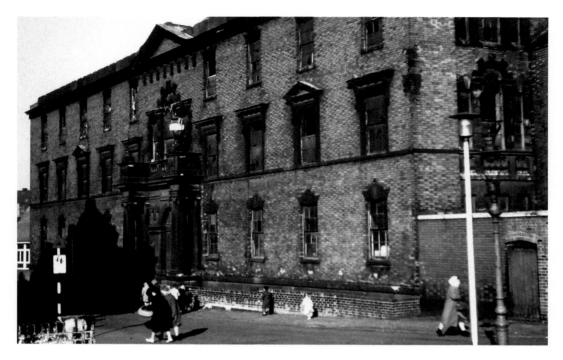

Alcock's Hill Pottery, Westport Road, Burslem, 1960s, and Housing on Alcock's Factory Site, 2020
The former Alcock's pottery factory was rebuilt in 1839 by the architect Thomas Stanley of Shelton and incorporated a Venetian window and pediment. It was described by historian John Ward as 'the most striking and ornamental object of its kind within the precincts of the borough'. It stood derelict for some time before being demolished in the 1960s, but is remembered through the autobiographical writing of Charles Shaw, who worked there in the 1840s and the photographs of Ernest Warrillow.

Old Town Hall, Burslem, 1958, and Haywood Sixth Form Academy, 2020

Warrillow's photograph captures the dignity of the Old Town Hall, opened in 1857. In addition to its civic functions, it was a cultural hub. In 1863, there were readings from Macbeth, 'interspersed with the performance of Locke's celebrated music'. In 1875, a Japanese troupe performed there, with balancing feats, rope-walking and butterfly tricks being the order of the day. A surviving advertising bill announces a concert to be given by Thomas Tomkinson's Royal Gypsy Children (for whom Gertie Gitana performed as a juvenile).

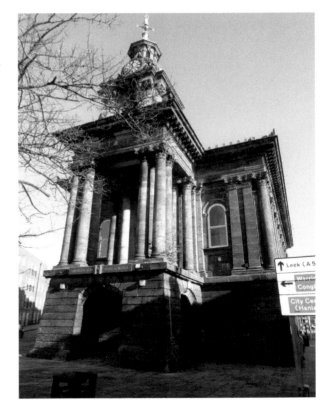

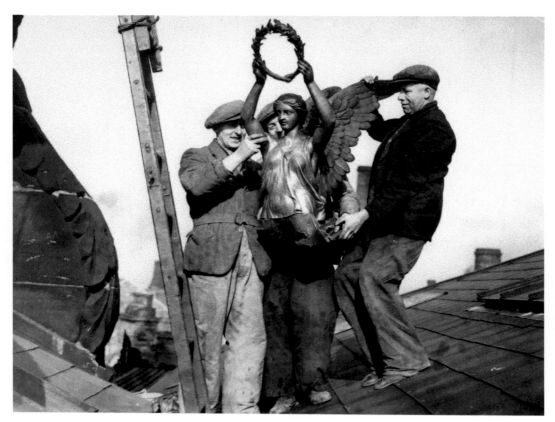

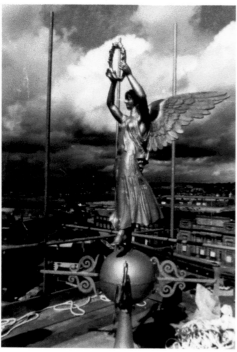

Old Town Hall, Burslem, Removing the Figure of Civic Victory, 1940, and Civic Victory, 1983
The photograph is from the collection of eminent Potteries historian Ernest Warrillow. The figure has fallen from the top of the town hall several times in its history – or has been taken down for restoration. The figure, renovated in 1998, was temporarily displayed in the foyer of the Potteries Museum. It was returned to the top of the town hall in October, 2001. The £5,000 cost of the renovation was met by the Heath family of Burslem, who ran three companies in the town.

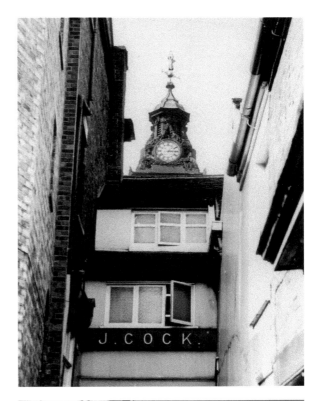

Brickhouse Street, Burslem, 1957, and Same View, 2020

Brickhouse Street is known by local people as Cock's Entry – deriving from James Cock's Magnet Drapery that formerly stood at the top of the entry, though coincidentally, a pub called the Cock once occupied the same site. This location fascinated artist and poet Arthur Berry, who wrote, 'Let us praise the sweet mystery of life, and let us praise the not-so-sweet mystery of life as well, for it all comes under Cock's Entry from time to time.'

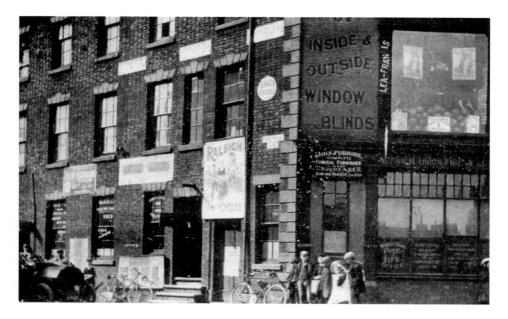

Lycett's Shop, Corner of Packhorse Lane and Liverpool Road/Westport Road, Burslem, date unknown, and Same View, 2020

A letter (2007) to *The Sentinel* from Michael Lycett of Bagnall conveyed that his grandmother, Florence Lily Bailey, lived at the New Inn, Burslem, with her parents until her marriage on 9 February 1910. She married Frank Lycett, whose father, Charles Taylor Lycett, ran his business opposite the New Inn. C. T. Lycett advertised himself as 'the great Cycle and Motor agent' operating from the Fountain Place Buildings. The premises later became Alcock's cycle and radio shop.

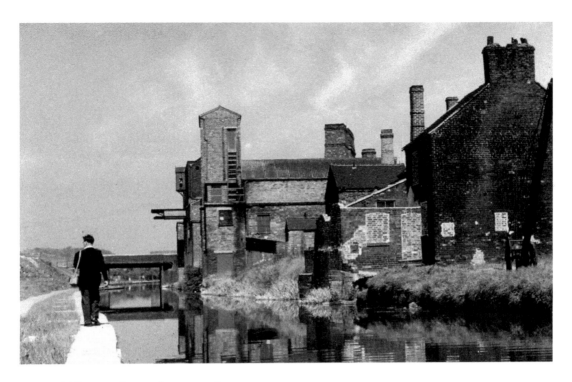

Middleport, date unknown and 2020

Ewart Morris's photograph shows the Trent and Mersey Canal passing through Middleport. 'Middle Port' by name doesn't seem to be mentioned before 1823. The Hargreaves map of 1832 shows us that Longport had grown the quicker, with relatively few properties in Middleport by that year. Port Vale Wharf is also seen on the map, indicating the impact of the canal. Later, businesses such as the Port Vale Flour Mills and Middleport Pottery overlooked the canal.

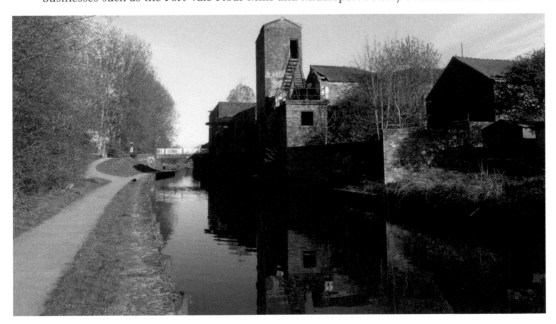

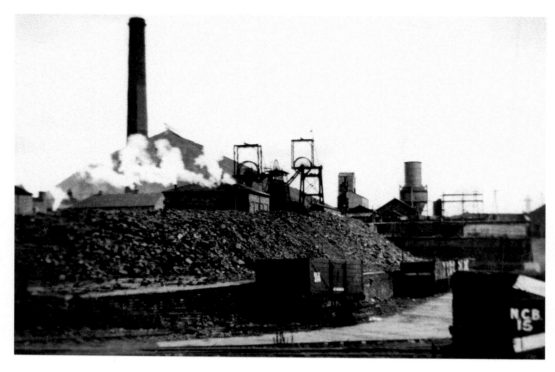

Sneyd Colliery, Burslem, date unknown, and Sneyd Hill Park, 2020

Sneyd Colliery and the adjoining village derived their names from the Sneyd family of Keele Hall, who had been local landowners. The company was known under several names during the time of its existence. It was known as C. B. May and Company until 1860 and as Sneyd Colliery Company (William and John Heath, Arthur Dean and W. A. Marsden Tellwright) until 3 December 1881. Afterwards, the proprietors were Sneyd Colliery and Brickworks Company Limited until 5 December 1900.

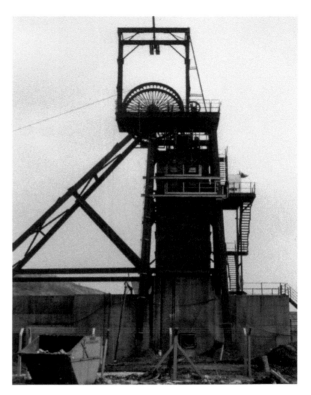

Sneyd Colliery Headgear, Burslem, 1985, and Sneyd Hill Park, 2020

After Nationalisation in 1947, the brickworks attached to Sneyd Colliery was formed into a separate company. William Tellwright was Chairman of Sneyd Brickworks Company Limited until he relinquished the position in 1952, but retained his directorship and continued as managing director up until his death in 1954. Burslem miner Joseph Griffiths, of Burslem, descended Sneyd Colliery on 10 April 1959 at the age of seventy-one – and on his Golden Wedding anniversary. He had worked underground at Sneyd for fifty-nine years.

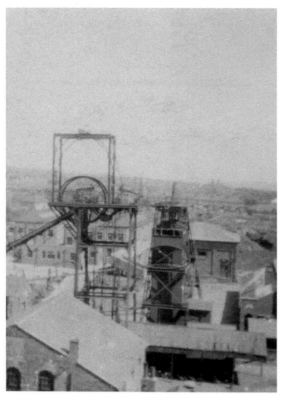

Sneyd Colliery, date unknown, and Sneyd Hill Park, 2020

The Sneyd Disaster on New Year's Day 1942 accounted for the lives of fifty-seven men. The workings at Sneyd Colliery were merged with Wolstanton Colliery as part of a modernisation scheme in July 1962. The first Sneyd coals were raised at Wolstanton in mid-June, and the last coal was brought up at Sneyd on Friday 6 July. One of the shafts there remained in use in order to lower maintenance workers into the workings and also to ventilation. Wolstanton Colliery itself closed in 1985.

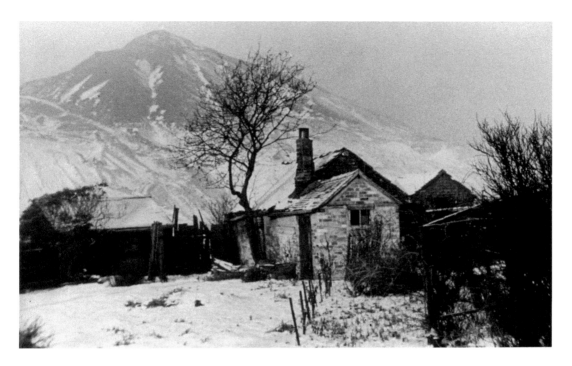

Sneyd Colliery Tip from Leek New Road, Sneyd Green, 1959, and Former Colliery Site in the Distance, from Leek New Road, 2020

Ewart Morris, who provided this photograph, often used to ask audiences to guess the location – with some people wondering whether or not it was the Swiss Alps being depicted! Whatever the climatic conditions, the pit spoil tips in the Potteries were a spectacular feature of the landscape. The site of the tip mound was later reclaimed and called Sneyd Hill Park. Just out of the picture to the right was Burslem Cemetery, still used for interments today.

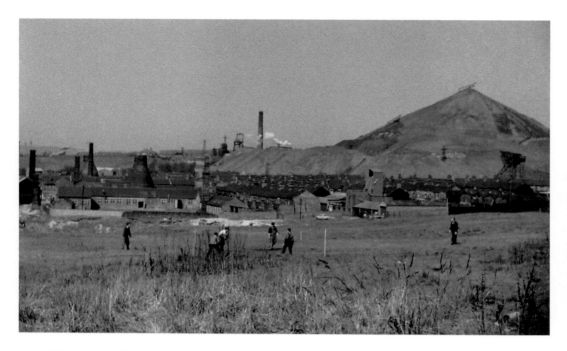

Sneyd Street (view from) 1964 and 2020

The 1877 Ordnance Survey map shows that the fields between Sneyd Street in Cobridge and Leek New Road were pocked with old coal and ironstone shafts.

The Stoke-on-Trent Official Handbook (1971–02) contained maps that illustrated how the industrial age had clung fast in the city notwithstanding the increasing number of reclamation schemes. An extensive brick and marl works was situated between Sneyd Street and Leek Road. Sneyd Street links Cobridge with Sneyd Green.

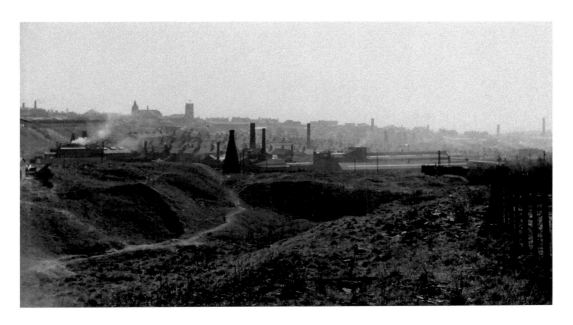

Sneyd Street (view from) 1964 and 2020 II

Here is another photograph illustrating the march of industry in this area. At the foot of Sneyd Street there now stands a Honda car garage and the Raven Pharmacy, opened in 2017. It was formerly the Raven public house but was originally the Village Tavern and briefly the Pot o' Beer. Adjacent to this, and easily missed, is a small monument that recalls the site of 'the Old School House' erected in 1766 and demolished in 1897.

Sneyd Hill at Junction with Nevada Lane, date unknown, and Similar View, *c.* 1970s, Both Photographs from the Ewart Morris Collection

The monochrome photograph shows Sneyd Hill, and on the right the former spoil tip of Sneyd Colliery, which was described by *The Sentinel* in 1971 as 'Stoke-on-Trent's mini-volcano'. It was still burning on account of sub-surface combustion. Arnold Bennett's biographer Margaret Drabble wrote in 1974, 'The public were asked if they wanted the slag heap flattened. No, they said. They liked their slag heap. They didn't mind its being landscaped, but they didn't want it taken away. Bennett would have liked that.'

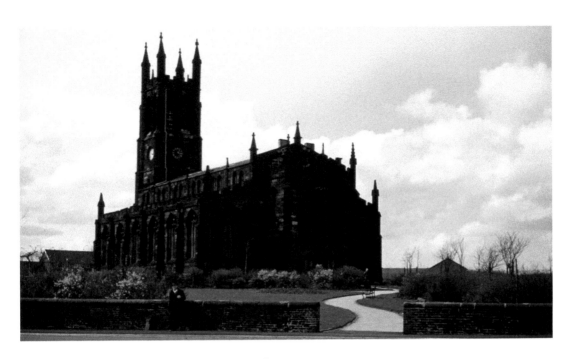

St Paul's Church, Dale Hall, *c.* 1960s and 2020

St Paul's Church, consecrated in 1831, was taken down in 1974. During demolition, pottery was found within its walls so that the wrecking team was ploughing through old stonework as well as vintage china hidden in the cavities. It was believed to have been planted there by master potter and antiquarian Enoch Wood (d. 1840). Around 250 pieces were later archived by museum staff. A new church was built on-site, described by historian Bill Morland as having the appearance of 'an outsize hot dog stall'.

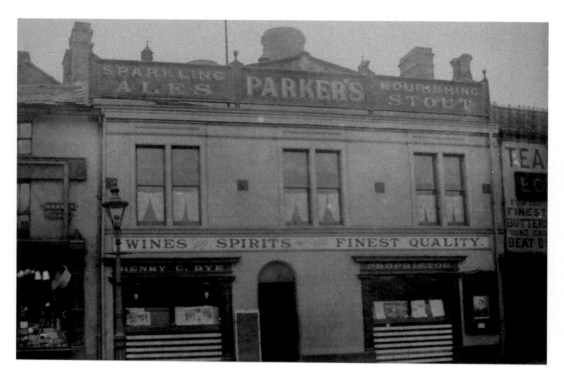

New Inn, Burslem, Early Twentieth Century and 2020

The New Inn was a prominent Burslem pub in the nineteenth century, being described by the *Staffordshire Advertiser* in 1800 as having a stable and other appurtenances attached. It still offered stabling for eight horses by 1874. It played host to meetings of the North Staffordshire Miners' Federation in the early 1880s and in the same decade had connections with Burslem Athletic Club. During a renovation of 1989, a well of 14 feet in depth was unearthed to the rear of the building.

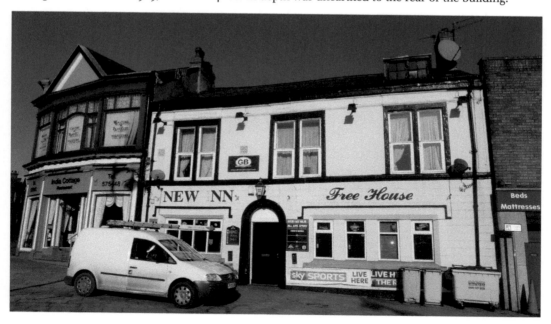

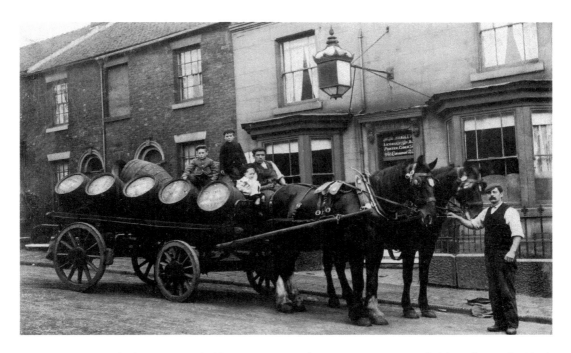

Bleak Inn, Bleak Street, Cobridge, *c.* 1903, and Orgreave Street, Cobridge, formerly Bleak Street, 2020

The Bleak Inn – perhaps not the most inviting name for licensed premises – was still listed as a beerhouse by 1907 when it was kept by proprietor Arthur Smith, though the 1912 trade directory has Elijah Whalley as the proprietor. An architect's plan of 1939, in the possession of the author, shows the Bleak Inn, then owned by Parker's Burslem Brewery incorporating four public rooms: a front bar, sitting room and two smoke rooms. The pub was reputedly demolished in the 1960s.

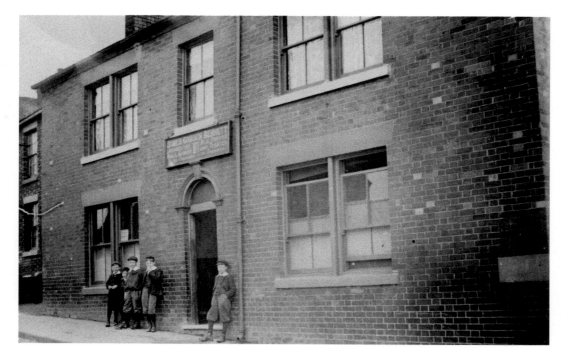

Brown Jug Inn, Sneyd Green, *c.* 1903, and Same Premises, Now Used for Business, 2020
Architect's plans for the Brown Jug Inn, Sneyd Street, Cobridge, drawn up by R. Dain and Sons in July 1903, are contained within the author's archive. The hostelry was then being leased to Parker's Burslem Brewery, with its vaults and its taproom bracketed a central passageway. There was a yard to the back plus stables and a coach house to its right. Other architect's plans for 1952 suggest that the pub was by then known as the Jug Inn.

WHITFIELD COLLIERY.

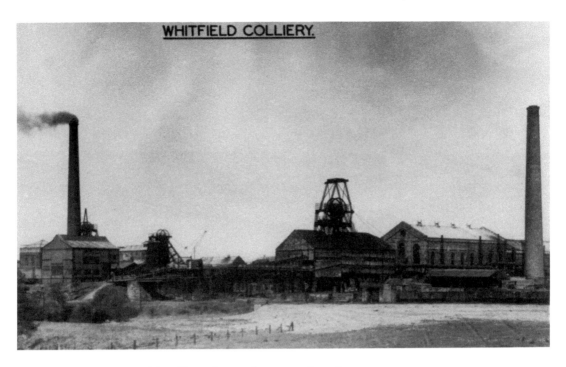

Chatterley Whitfield Colliery, date unknown and 1996

Hugh Henshall Williamson (d. 1867) rapidly developed this site for coal production in the 1860s, and between 1873 and 1890 much of the colliery's coal fed the furnaces belonging to the Chatterley Iron Company Ltd. Subsequently, a new company called Chatterley Whitfield Collieries Ltd came into being on 1 January 1891, continuing as such until the coal industry was nationalised in 1947. Both pictures show the rear of the Hesketh heapstead, headgear and winding shed.

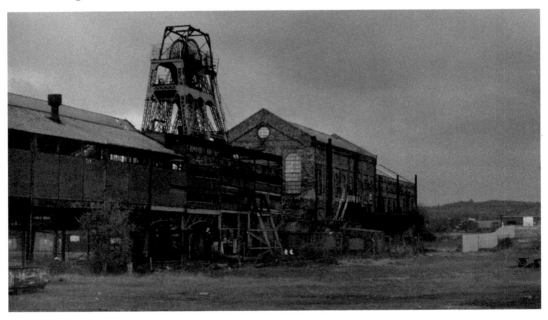

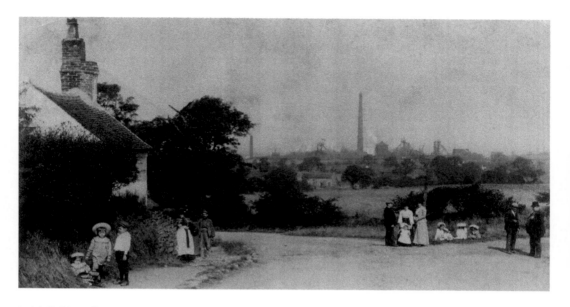

Whitfield Colliery Taken from Junction of Whitfield Road and Wilding Road, 1891, and Former Colliery/Museum Site, 2020

Ten years before this picture was taken, Whitfield Colliery suffered a pit disaster. It took place in February 1881 in the Institute workings and was caused by the misuse of an underground blacksmith's shop that had been established near to the pit bottom when the Institute shaft had been sunk in 1876. Explosions destroyed the nearby Laura pit and led to the deaths of a reported twenty-four men and boys. Both pictures offer a distant view of the site.

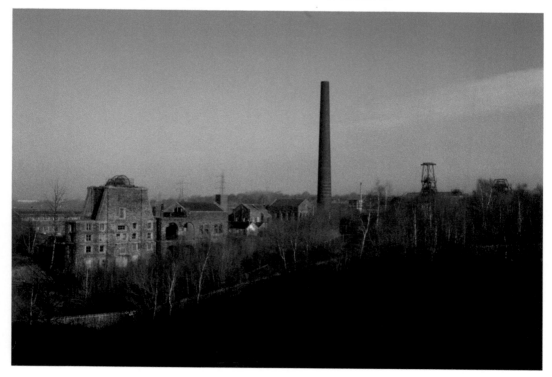

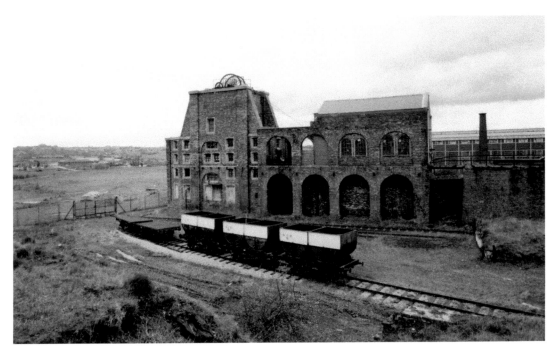

Winstanley Shaft, Chatterley Whitfield Colliery, date unknown and 2019
In 1912 a minor explosion in this colliery's Middle Pit highlighted the need for better ventilation, giving rise to the sinking of a new shaft. It was completed to a depth of 700 feet in January 1914. Its enclosed headgear and engine house were constructed mainly in brick, and to a German design. It was sunk for ventilation purposes only, and was never used for coal-drawing, though men and materials were carried. The recent photograph illustrates the growing decrepitude of the site.

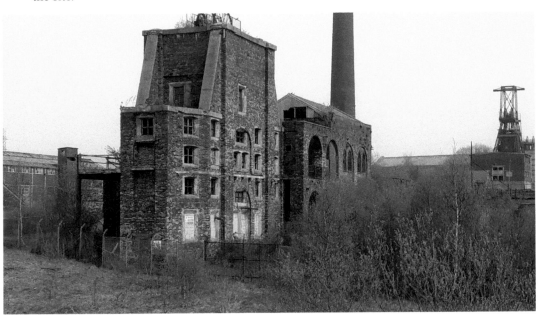

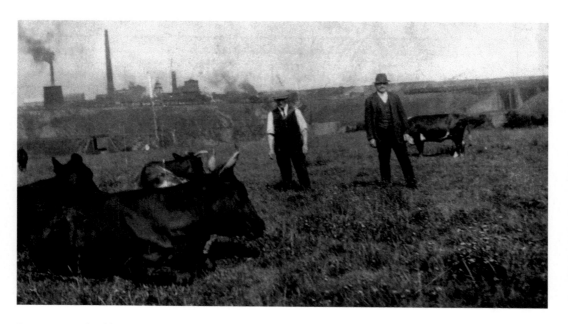

Fegg Hayes looking towards Chatterley Whitfield Colliery, 1928, and Similar View from Oxford Road, 2020

The proximity of the mining village of Fegg Hayes is clearly shown in this photograph which shows farmer Thomas Holland (right) who kept cows and who also ran a butcher's shop. His daughter married William Sutton (left) after which the Sutton family ran the butcher's shop. The shop later made 'savoury ducks', consisting of liver, gravy and a little dough cooked in an oven – the precursor of faggots. At one time, Fegg Hayes also had as many as four chip shops!

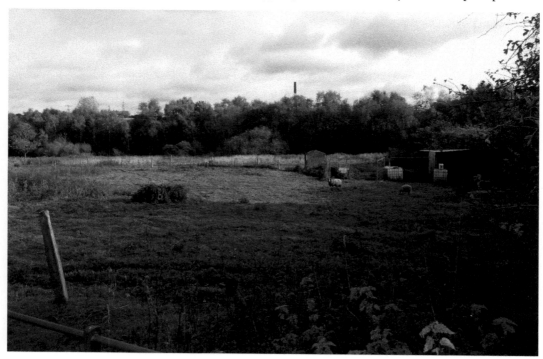

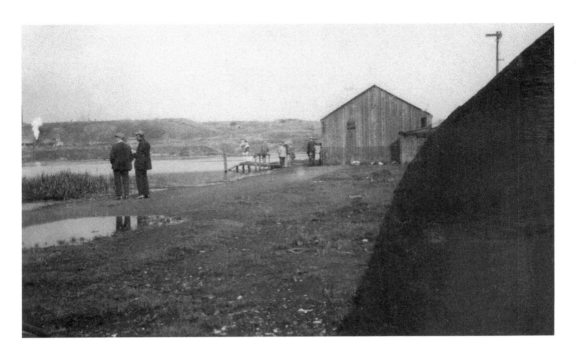

Westport Lake Boathouse, 1900, and Visitor Centre, 2020

Westport lake was developed as an entertainment resort by local farmer Smith Shirley (d. 1925), whose late Victorian reclamation scheme was arguably more ambitious than the one that gave us Westport Lake Water Park, opened in 1971. He used shraff from the loc potteries to fill up water-sodden ground in the vicinity. Shirley built an open-air dance floor which at some stage appears to have been replaced by a dance hall/pavilion and even offered a fairground at various times.

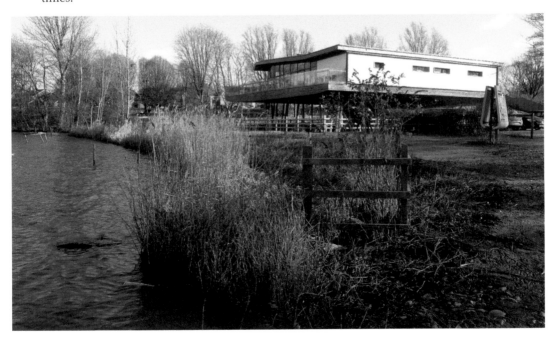

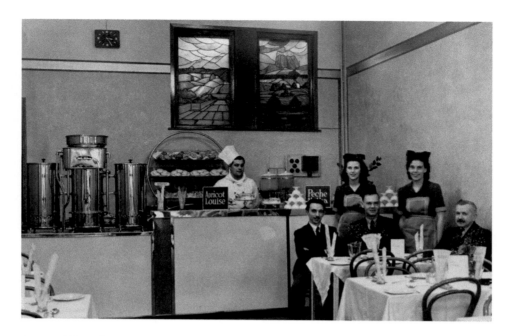

Emanuelli's Café Continental with Hector Emanuelli Behind the Counter and Approximate High Street Location of Café, 2020

The Café Continental stood opposite the Ritz Cinema in Tunstall. Giovanni Emanuelli and his three sons originally started the business in the 1930s, pushing ice-cream carts around the town. They prospered and in later years had twenty vehicles on the roads. The family also had an ice-cream factory opened in 1950 on the outskirts of Biddulph on a 4-acre site known as The Paddock. The business eventually wound up in 1966.

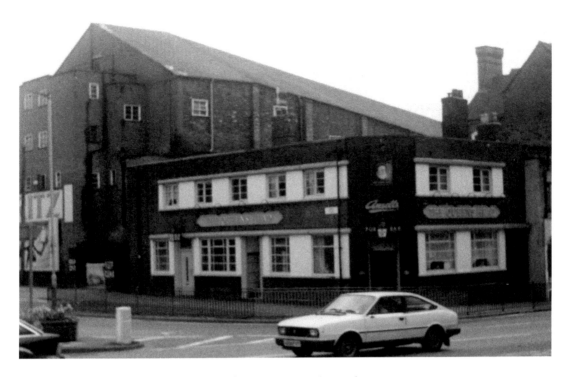

Queen's Head, Tunstall, 1990s, and Former Queen's Head, 2020

A trade directory of 1907 has George Cox Cooper keeping the Queen's Head Hotel in High Street. He was listed as one of fifty-eight publicans keeping beerhouses in Tunstall, there being an additional twelve publicans keeping fully licensed premises. In recent years, the building was for a short while Betty's Diner, a vibrant and cheerful café-restaurant that paid homage to the overtly sexy cartoon character Betty Boop who first appeared in 1930.

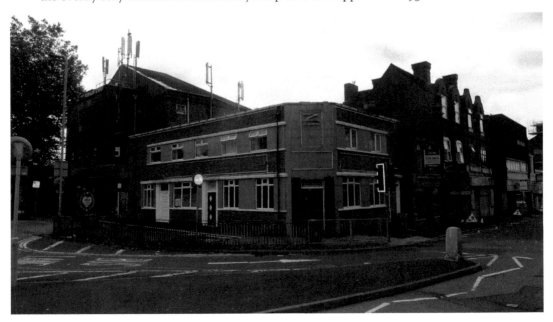

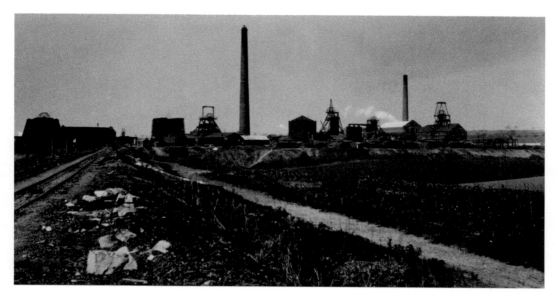

Chatterley Whitfield Colliery, 1936, and View from Top of Spoil Tip, 1992
The Colliery was closed in 1977 and the Chatterley Whitfield Mining Museum Trust opened the museum in 1979. It was reliant on much volunteer or government-sponsored talent, including ex-miner guides who conducted underground tours and talented surface guides and education staff. Former receptionist Laura Butler, pictured here, has taken many photographs of the site over the years. Tragically, the museum went into liquidation in 1993, though it recently became a TV star when the Lloyds Bank black horse cantered through part of the derelict site.

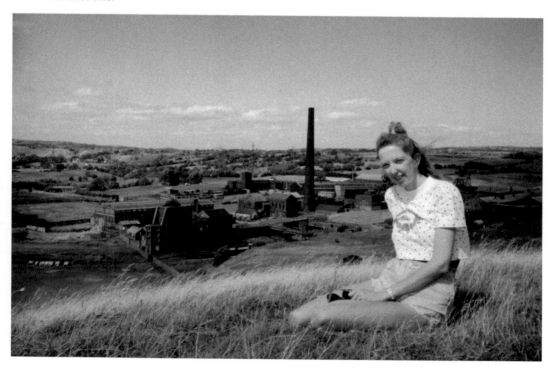

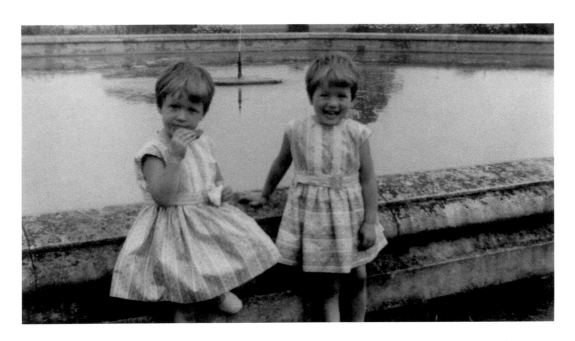

Trentham Gardens, Glenys and Julie Edwards, *c.* 1967, and Trentham Gardens and Mervyn Edwards, *c.* 1990

Trentham Gardens, with its camping and caravanning facilities, lake and Italian gardens, has been a popular resort for generations. As the colour photograph shows, it was favoured by the organisers of the Potteries Marathon annual event as the location of the race's finish. The fountain feature seen here was ideal for cooling the blisters of those – such as the author, pictured here – who had completed the 26.2-mile race.

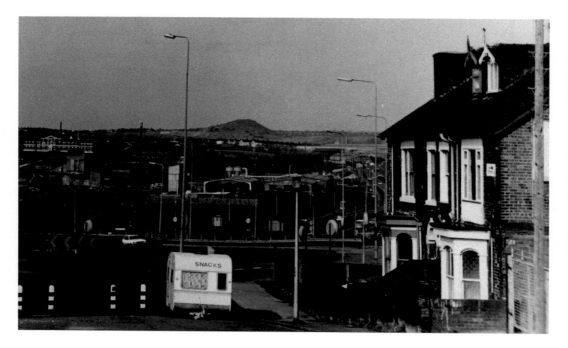

Etruria Road, Basford Bank, date unknown and 2020

Artist and photographer Ted Simpkin's excellent picture shows old houses in Bank Terrace on the right and a fascinating view over Etruria and Hanley. We recall the famous Warrillow photograph of Ernest James Merrick, one of the last lamplighters. He is depicted using a long pole to ignite the gas, with the Basford Bank houses just behind him and the magnificent panorama of Shelton Bar iron and steelworks – with its ogre-like spoil tips and industrial chimneys – in the middle distance.

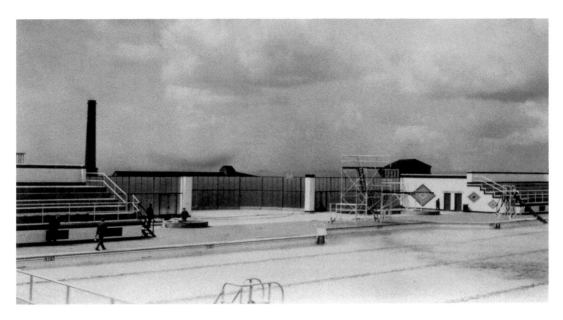

Smallthorne Swimming Baths, date unknown, and Esso Petrol Station, 2020
The bath was opened in 1938 by the directors of Sneyd Colliery, nearby, and was partly intended as a reservoir of water for the pit. It was the largest bath in the Midlands, with room for 1,200 swimmers. In September, 1939, and with the outbreak of war, the baths was closed, and was later taken over by the National Fire Service for an emergency water supply. Demolition followed in the 1960s. A petrol station and a few small shops now stand on-site.

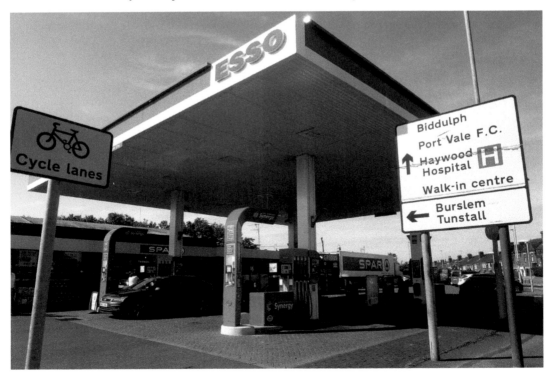

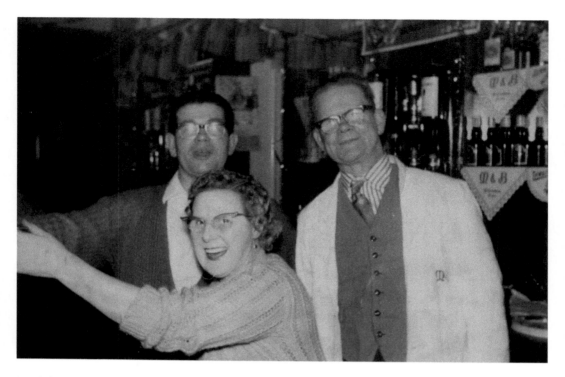

Bradeley WMC, *c.* 1960, and Jo's Pantry, 2017

Pictured here are Jack and Minnie Lancett with George Lancett looking on. The WMC later moved to Moorland View. The club organised treats for senior citizens, gifts to the longest-married couple/oldest members and other community events. In 1971, the local press reported that steward Jack and his wife had left the club to become stewards at Norton Central Club. The older club premises survive today as a shop, Jo's Pantry.

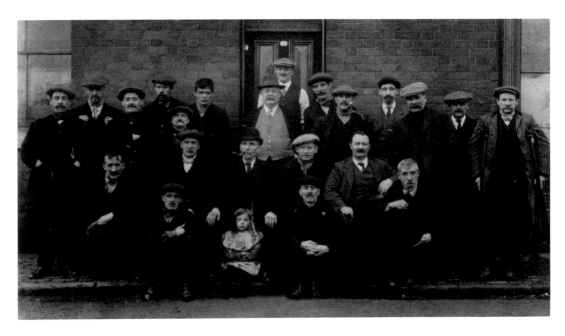

Talbot, Bradeley, *c.* 1910 and 2015

Henry Lees (d. 1926) was the licensee of the Talbot at the time this picture was taken. His grandson John Lees was born in the Talbot in 1941. John recalls that local miners would often snare rabbits in the nearby fields, afterwards putting them in a large pot with carrots and onions and heating it all up on the pub's stove pot for the consumption of customers. The miners chewed Condor twist and spat it into spittoons, which John had to clean every Saturday morning.

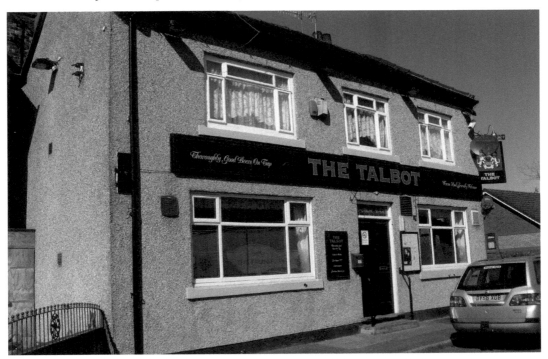

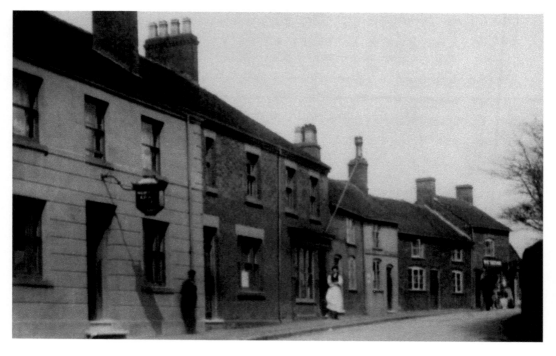

Norton Arms and Leek Road, date unknown, and Same View, 2020

This pub stood at a busy road junction, which was all the more reason not to leave a parked vehicle outside. However, in 1877, Thomas Clarke did exactly this, by going into the pub – then known as the Cock Inn – for a drink, and leaving his horse and cart outside unattended. He was fined 5s. and costs. When up for auction in 1906 this splendid pub incorporated a large assembly room, stable with loft over and coach house.

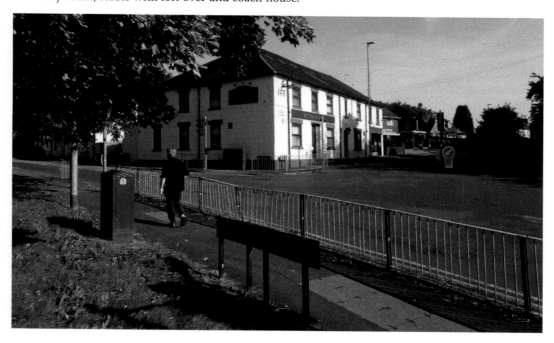

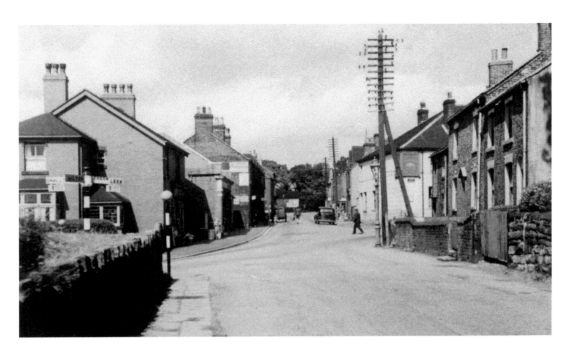

Norton Crossroads from Norton Lane, and Same View, 2020

The Norton Arms, still standing but no longer licensed premises, was an obvious landmark in Norton but was by no means the only hostelry in the vicinity. There was also the Duke of Wellington on Endon Road, the Sperling – opened at Pound Gardens in 1960 – the New Inn (later the Farmer) and the Royal Oak at Ball Green and the Robin Hood on the road to Smallthorne. The last mentioned is still trading.

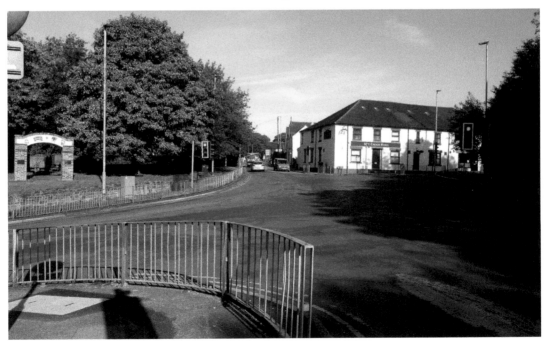

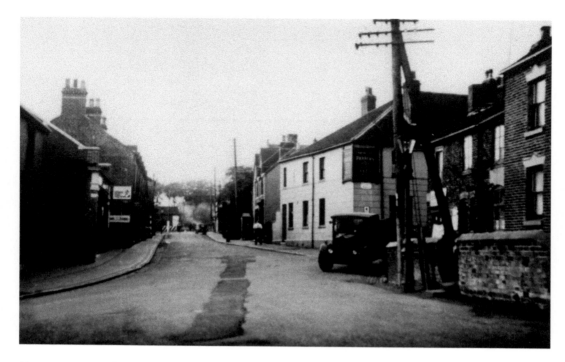

Norton Crossroads on Old Picture Card, date unknown, and Same View, 2020

David Harvey ('Some Personal Memoirs') remembered some of the traffic on these roads in the earlier twentieth century: 'Much of the local transport work and road work was done by local farmers and others who kept horses. Long before I started school, I remember my father and older brothers doing haulage work with the horses. Coal was hauled from the collieries to the miners' houses for the charge of 1d per cwt per mile.'

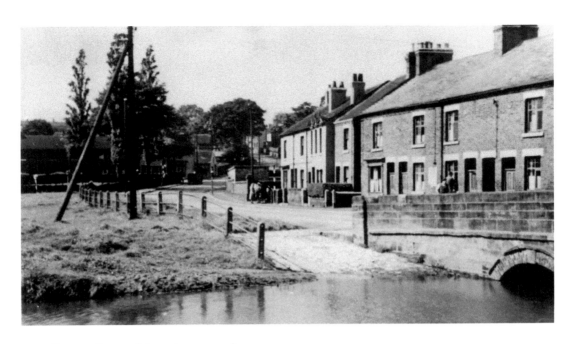

Norton Green, date unknown and 2020

Norton Green's public house is the Foaming Quart and its pub sign, on a surviving photograph of the early twentieth century, tells us that it was kept by James Mayer, 'licensed to sell ale, beer and porter'. The Mayer family ran the pub from the mid-nineteenth century until the 1920s. Former international darts player Maureen Flowers was born at the Foaming Quart, which had been kept by family. She married John Flowers in 1971 and they kept it until 1978.

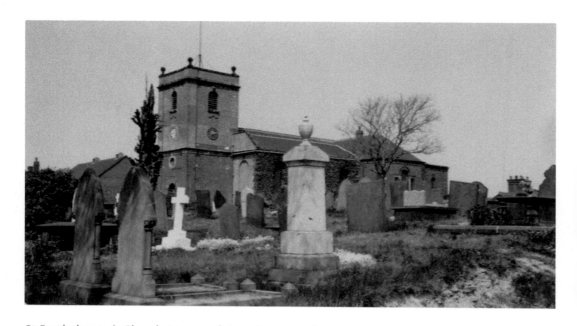

St Bartholomew's Church, Norton, date unknown and 2020

The church in Norton is believed to have originated in the twelfth century and was first dedicated to St Nicholas. It was rebuilt in 1737–38, the architect being Richard Trubshaw. The Bellringer coal seam ran directly below the tower and as a consequence, the church began to break into two parts on account of subsidence. It was extended in 1914, with the nearby Whitfield Colliery donating £150 towards the project. During a restoration of 1949, twelfth-century timbers and stonework were found.

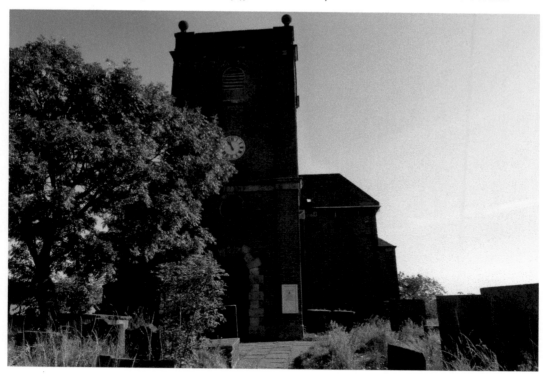